IMAGES
of America
AROUND
LYNCHBURG

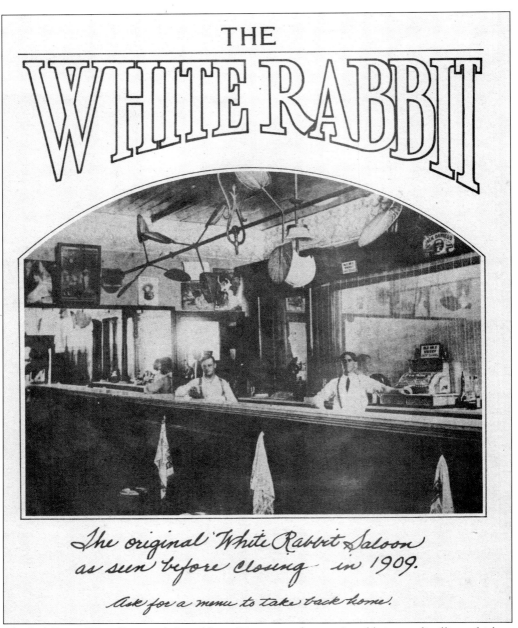

The Jack Daniel Distillery made Lynchburg, Tennessee, famous. In addition to distilling whiskey, Daniel sold the spirit in his local saloons. This shows the interior of one of these saloons, the White Rabbit, which was located on the town square. The White Rabbit closed in 1909 after the onset of Prohibition in Tennessee. (Courtesy of Annie Lou Tomlin.)

ON THE COVER: The four Motlow boys pose for a photograph inside the old office building at the Jack Daniel Distillery. Pictured are, from left to right, Conner, Robert, Evans, and Reagor Motlow. The death of Jack Daniel passed ownership of the distillery to his nephew Lem Motlow, and with the help of the Motlow boys, the distillery has survived and prospered, becoming the global icon it is today.

IMAGES
of America

AROUND LYNCHBURG

Jillian Rael

Copyright © 2012 by Jillian Rael
ISBN 978-0-7385-9147-6

Published by Arcadia Publishing
Charleston, South Carolina

Printed in the United States of America

Library of Congress Control Number: 2011939986

For all general information, please contact Arcadia Publishing:
Telephone 843-853-2070
Fax 843-853-0044
E-mail sales@arcadiapublishing.com
For customer service and orders:
Toll-Free 1-888-313-2665

Visit us on the Internet at www.arcadiapublishing.com

To all those who endeavor to keep our history and heritage alive.

CONTENTS

Acknowledgments		6
Introduction		7
1.	The Early Years	9
2.	Jack Daniel's Tennessee Whiskey	37
3.	Schools	59
4.	Buildings and Businesses	91
5.	The Modern Years	115
Bibliography		127

Acknowledgments

The completion of this book has been in no way an individual effort, and I would like to thank all those who have contributed pictures and stories. However, even before work began, I was encouraged and supported by several people who undoubtedly deserve recognition. I would like to thank my professors at the University of Alabama in Huntsville: Dr. Lillian Joyce, Dr. David Stewart, Jose Betancourt, Dr. John Kvach, and—most importantly—Martha Vines, who not only planted the seed for this book but who also put me in contact with Arcadia Publishing. I offer my many thanks to you all for your insurmountable belief in my capabilities to finish this book while also beginning graduate school.

While numerous individuals and organizations contributed to the contents of *Around Lynchburg*, a few deserve very special recognition. Peggy Gold of the Moore County Public Library has gone beyond the call of duty by allowing me access to all the library's resources and offering me her unwavering support throughout. I thank George Stone and all the members of the Moore County Historical and Genealogical Society for their support as well as access to their photograph archives and previous scholarship on Moore County's history. Thank you to Nelson Eddy at DVL Public Relations and Advertising for all your work in providing photographs and information on the Jack Daniel Distillery; you were a lifesaver! As for individual contributors, I offer my special thanks to Louise Ervin and Ike Farrar. Both have been sources for immense local history and countless photographs. I have enjoyed my time with you both and am privileged to now call you my friends.

Of course, none of this would be possible without the love and support of my family. Thank you all. Most importantly, I thank my loving husband, Travis, for your encouragement in this and all my crazy projects. I could not do what I do without you by my side.

Last, but certainly not least, I must thank my editor, Elizabeth Bray, for all her wisdom and encouragement. I could never have done it without you!

Introduction

No one knows for sure how Lynchburg got its name, but stories abound nonetheless. One well-known tale holds that the name stemmed from a beech tree that once stood near the center of town. In the early days, citizens preferred to take justice into their own hands, and punishments for crimes took the shape of public whippings and hangings. "Judge Lynch," as the tree became known, was the site of these acts of vigilance, leaving Lynchburg as its namesake. However, another story sheds a more positive light on the origins of the town name. This narrative claims that a shoemaker, along with two other men, came from Virginia to settle the area at about the same time that the town was created, and it was in remembrance of their hometown that Lynchburg received its name.

Regardless of how it was named, Lynchburg is known to have existed as a town since about 1818. It was at this time that Thomas Roundtree, the original owner of the land encompassing Lynchburg, laid out the early town and sold the lots at auction; however, it was recognized and incorporated by the Tennessee General Assembly during its 1841–1842 sessions. In July 1872, the town was established as the seat of the newly formed Moore County by popular vote. While Lynchburg is the most well-known area of Moore County, it is comprised of numerous small communities, each of which has significantly contributed to the overall history of the area.

Nestled in Tennessee's Central Basin, Moore County, named in honor of Gen. William Moore, was created on December 14, 1871, by the Tennessee General Assembly. An early settler of Lincoln County, General Moore was also a veteran of the War of 1812 and a longtime member of the Tennessee Legislature, serving four terms. Moore County was originally to be carved from four parent counties: Bedford, Lincoln, Franklin, and Coffee. However, by state mandate, a county was excluded if the proposed boundary brought the overall surface area below 500 square miles; this technicality resulted in Coffee County's exclusion. The remaining area of Moore County measures 170 square miles, making it the second-smallest county in the state.

The first meeting of Moore County's commissioners was held on January 6, 1872, at Lynchburg. These commissioners appointed a committee to divide the county into 11 civil districts: Lynchburg, Ridgeville, Marble Hill, Reed's Store, Tucker Creek, Waggoner's, Prosser's Store, Charity, County Line, Hurricane Church, and William B. Smith's Mill. While many of these communities no longer exist, others remain but live on only in name. These communities (and several others like them) often consisted of a general store, at least one church, and a school. Some even possessed a post office, a blacksmith, and a gristmill. Lynchburg remained the largest town center, and boasted five dry goods houses, one drugstore, two flour mills, a tannery, and three saloons by 1874. The existence of multiple saloons in town sheds light on the industry that made Lynchburg and Moore County famous.

The production of whiskey remains the county's primary industry. Although Lynchburg has become famous for Jack Daniel's whiskey, the county has been home to numerous stills throughout its history. In fact, it is believed that the earliest distillery was built around 1812 not far from

where Mr. Jack later established his operation. By the 1880s, when Goodspeed wrote his early history of the area, 15 distilleries were registered in Moore County. Samuel Isaacs, for example, was in possession of two distilleries in 1825, one in partnership with John Silvertooth. Tolley and Eaton's distillery was reportedly built around 1877 in the County Line community and was said to be the largest sour mash distillery in the state of Tennessee. The operation was able to process 98 bushels of corn, resulting in 300 gallons of whiskey per day. Jack Daniel's operation, built in 1876 at Cave Spring, followed closely behind Tolley and Eaton, processing 50 bushels of corn and 150 gallons of whiskey per day. It was said that if all 15 distilleries ran at full capacity for six months, they would produce 202,160 gallons (or 5,054 barrels) of whiskey. Goodspeed estimated this massive amount of whiskey to be worth about $404,320 in the 1880s.

With the mass production of whiskey, these enterprises consumed enormous amounts of corn and wood, in turn feeding local economies. Therefore, it is no surprise that following whiskey production, agriculture has been and remains the second-largest enterprise in Moore County. These two industries have a long history of mutual cooperation that exists even today. Jack Daniel's whiskey is still produced using the "Lincoln County Process," which incorporates charcoal filtering and fresh spring water in conjunction with corn (or sour mash). As in the old days, the distillery still produces its own charcoal directly on the grounds and provides the by-products of the corn and water, locally known as "slop," to local farmers for livestock feed.

While other distillers did not survive the competition or the effects of Prohibition, Mr. Jack's operation thrives today. With the help of his capable and cunning nephews and their sons, Jack Daniel's Tennessee Whiskey remains a source of spirited enjoyment for people all over the world. The immense popularity of the operation has forever placed Lynchburg and Moore County on the map, and countless numbers of visitors tour the distillery every year, providing a thriving economy interlaced with small-town pride and Southern hospitality.

Although Mr. Jack and his distillery are integral to the history of Moore County, the area possesses a rich tapestry of history and folklore unto itself. From the earliest settlers to the veterans of the Civil War and all the way up to those who keep the spirit of Lynchburg alive today, this book intends to shed light on those who have made the area what it is now. Moreover, I have also attempted to present images and stories of people and communities that live on only in memory in an attempt to keep those memories from fading forever. Historic buildings, events, and people provide the texture for our present selves and circumstances, and photographs are an excellent medium through which to understand such a past. Therefore, I have undertaken this project as an act of conscious preservation hoping that readers will bring history to life through collected memory.

One
THE EARLY YEARS

Prior to 1806, the area that would later become Moore County belonged to the Cherokee tribe. It was only after the Indian Treaties of 1805 and 1806 that white settlers began to migrate to the area from the Eastern Seaboard. Of the counties that were divided to create Moore County, both Bedford and Franklin Counties were established in 1807, and Lincoln County was established in 1809. By 1812, the first gristmill had been constructed in what would later become the town of Lynchburg. Around the same time, a whiskey distillery was created at Cave Spring, which would in the 1860s become the home of the Jack Daniel Distillery.

The county's early settlers traveled hundreds of miles, and through their will and determination many established familial lineages that still survive in Moore County today. Some of the early names that have endured through the years are Tolley, Daniel, Bobo, Ervin, Holt, Wiseman, Dance, Haslett, Farrar, Eslick, and of course Motlow. Many of these names will appear frequently in the pages that follow.

This chapter focuses on the early days of the Moore County area through about the 1920s, mostly depicting the stories of the people who made the area around Lynchburg what it is.

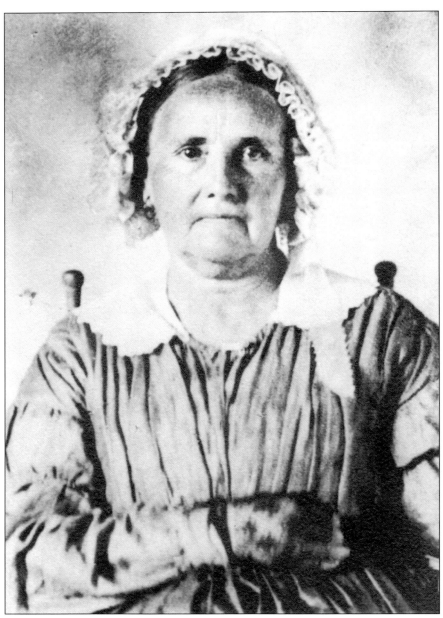

Mary Goodlett married Zadock Motlow in Greenville County, South Carolina, on February 26, 1784. Zadock was the son of Agnes McElhaney and John Motlow Jr., who was born in 1757 in Essex County, Virginia, and served as an officer in the Revolutionary War. After the death of John in 1812, Goodlett migrated to the Lynchburg area in 1813 with Zadock and McElhaney. It is said that the Motlows rode horseback to Tennessee from South Carolina and made three trips back to their home state during their lifetimes. Zadock and Mary were the parents of Felix "Stump" Motlow, who was born in Lincoln County. In December 1868, Felix married Finetta Josephine Daniel, the sister of Jack Daniel, thus establishing the lineage that created a whiskey dynasty. Mary Goodlett Motlow died on August 14, 1825, in Moore County and is buried in the Pioneer Cemetery. (Courtesy of the Moore County Public Library.)

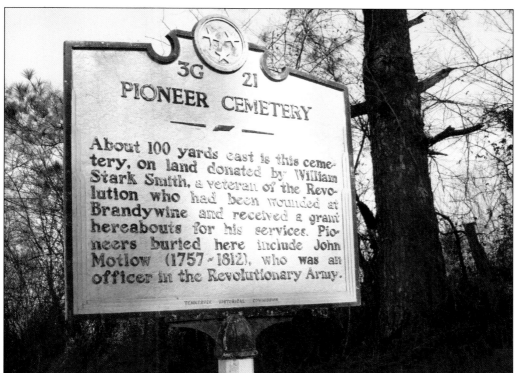

The Pioneer Cemetery, located just northeast of the Lynchburg Square, is one of the oldest cemeteries in Moore County. Many of the area's earliest settlers are buried here, including many of the original Motlows who arrived from South Carolina in 1813. Many of the graves are identified with simple fieldstones or left completely unmarked. (Author's collection.)

Mary Jane Mitchell was born on December 18, 1833, and later married George W. Gattis. Mary Jane's daughter Louisa Ann Gattis Owens died at an early age in 1888; Louisa's two small children, John Wesley and Claude Lee Owens, were primarily raised by their grandmother, Mary Jane. (Courtesy of Louise Ervin.)

John Wesley Owens was born on August 16, 1883, at Gattis Town, Lincoln County. He married Nancy Elizabeth Snow, who was born on December 22, 1886, in the Fuga community. John was a prosperous farmer near Lois for many years. In 1946, they left their farm and moved to Lynchburg, purchasing a house on Poplar Street (now known as Majors Boulevard). (Courtesy of Louise Ervin.)

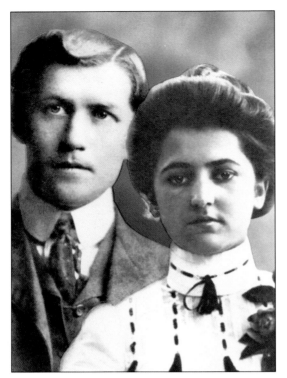

Martha "Mattie" Owens was born around 1862 to John and Elizabeth Brown Owens. She married Robert W. "Bob" Smith. Robert donated the logs that were used to build the Snow Schoolhouse, which later became known as the Fuga School. Martha Owens died in 1889. (Courtesy of Louise Ervin.)

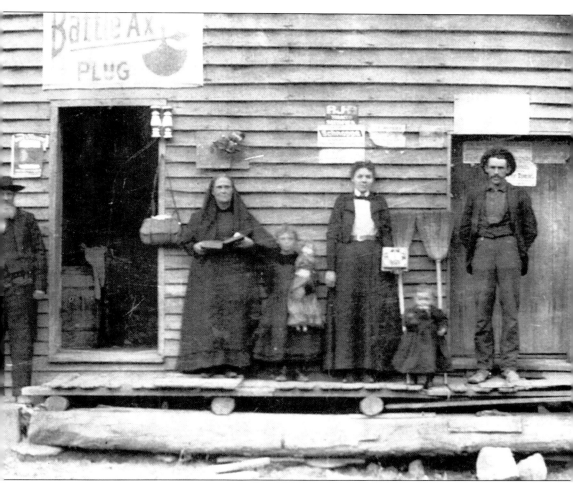

The Fuga community was located approximately seven miles south of Lynchburg and was believed to have been originally settled along the dry prong of Ferris Creek. The family of Nathaniel Reed, along with the Cashions, Smiths, and Snows, was among the earliest settlers. Reed's grandson James Reed Smith began operating a general merchandise store by 1895. This undated photograph of James R. Smith's store was likely intended to advertise some of the goods available for sale. Pictured here are, from left to right, James R. Smith, Rebecca Syler Smith (James's wife), Mimi Spencer, Nina Jeans (James's niece and employee), Beulah Snow, and George Smith. In addition to the general store, a gristmill was operational within Fuga and was built by John Reed, the son of Nathaniel Reed, before 1854. (Courtesy of Louise Ervin.)

The Reed family farm still contains some of the remnants of the gristmill that was operational in Fuga by 1854. It is known that Sammie (pictured here as an adult) and her husband, William, sharecropped the farm; records show that J.D. Henderson, one such sharecropper, was recognized as one of the area's best tobacco growers. (Courtesy of Louise Ervin.)

A close descendant of early pioneer Nathaniel Reed, Sammie Reed Cashion (pictured here as an infant) was the daughter of Julia Ervin and Tobe Reed. On August 26, 1885, Sammie married William "Will" Cashion, a farmer in the Fuga, Fourth District area in Moore County. (Courtesy of Louise Ervin.)

As in many counties, land grants were typical means for many early settlers to obtain land and move into a new area. This 1847 land grant gave Sterling Wiseman 3.25 acres in what is now the County Line area. As indicated on the grant, the area was part of Bedford County at the time. Sterling Wiseman was born in North Carolina on October 29, 1816, and died in Moore County in 1894. He is buried at the Wiseman Cemetery. Wiseman's twin sons, Elisha and Elijah, were born in 1842 and served in the Confederate army. The two served in the Tennessee 17th Infantry Battalion and fought in the battle of Stones River, Chickamauga, and at others in Virginia and Kentucky. Elisha eventually donated the land for Wiseman Cemetery, where he was buried in 1914. (Courtesy of Louise Ervin.)

Although Moore County had not been officially established at the time the South seceded, the area that later formed the county contributed tirelessly to the Civil War effort. Confederate loyalty was abundant in the area, and militias began to form when a February 1861 state vote resulted in favor of remaining in the Union. Men from Fayetteville, Lynchburg, Mulberry, Winchester, and Tullahoma gathered to aid the Confederate effort despite the state's decision. These men became the military unit known as the "First Confederate Infantry" or "Turney's First Tennessee Infantry." Though no major battles were fought on Moore County soil, the area served as an important supply source for the Confederates, contributing massive amounts of salt pork for the soldiers. In July 1863, with the ending of the Tullahoma Campaign, the area came under Union occupation and remained so until the war's end. (Courtesy of the Moore County Public Library.)

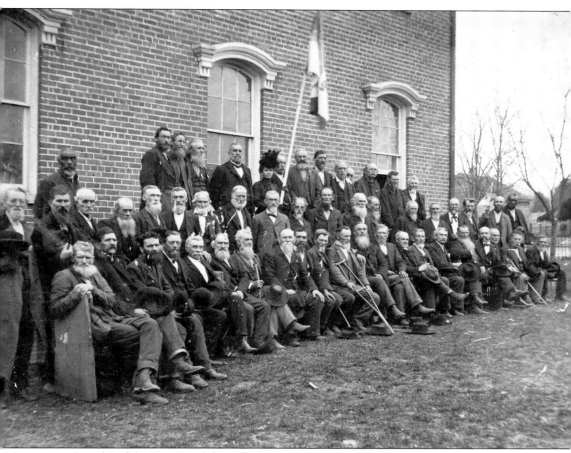

Companies D and E of the First Confederate Infantry were composed of men from Moore County. Company K of the Eighth Tennessee Infantry was established in nearby Mulberry and included men from the Moore County area. Company K served with the regiment in both South Carolina and Virginia before returning to Tennessee. Members of the Eighth Tennessee held Confederate reunions in Lynchburg at various times in history. In this c. 1900 image, veterans pose for a photograph in front of the Moore County Courthouse. Second from the right in the second row is Henry Morgan, for whom Morgan Street is now named. The two African American men pictured, like several other company members, remained with the regiment at its 1865 surrender in North Carolina. George Dance, believed to be among the African Americans pictured, was a former slave who once served as an assistant to local surgeon Dr. Stephen E.H. Dance. (Courtesy of the Moore County Public Library.)

This article by F.W. (presumed to be Felix Waggoner) Motlow first appeared in the *Lynchburg Falcon* in 1900. The story was republished by the *Moore County News* at a later, unknown date. The bottom portion of the article urges residents to keep copies of the paper or clip and, in turn, "keep faith with the Confederate soldiers who valiantly defended their homeland." (Courtesy of the Moore County Public Library.)

The 100-man company known as the Nathan Bedford Forrest Escort consisted of many men from the Moore County area. Among the escort was Jasper Newton Taylor, who practiced medicine in Lynchburg with Dr. Ezekiel Young Salmon. Taylor later chose orators for the 1887 reunion. A group of Confederate veterans is pictured here; however, the date and location of the reunion is unknown. (Courtesy of the Moore County Public Library.)

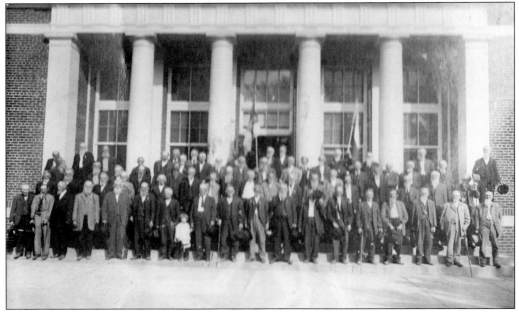

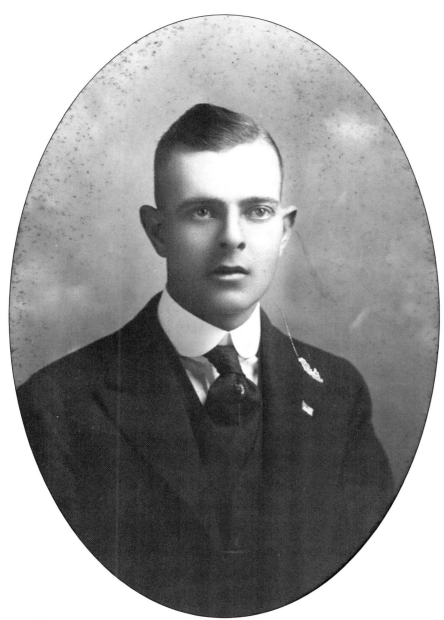

Henry Bradshaw Morgan was born on October 14, 1843, in the County Line community of Moore County. In 1861, he enlisted in the 41st Tennessee Infantry of the Confederacy and fought in numerous battles, including Vicksburg and Franklin, where he lost an arm. He is said to have regularly spoken about his wartime experiences. In 1868, he married Mary Jane Bryant Reese, the daughter of his business partner. From 1893 to 1897, Morgan served as the Lynchburg postmaster and was named one of the directors of the Farmers Bank in 1889. In the great fire of 1913, Morgan lost the building, located on the Lynchburg Square, where he and his partner ran J.L. Bryant and Company. From 1907 until 1924, Morgan served as the register of deeds in Moore County. He died on June 24, 1923, and was buried at the Odd Fellows and Masonic Cemetery in his Confederate uniform. (Courtesy of the Moore County Public Library.)

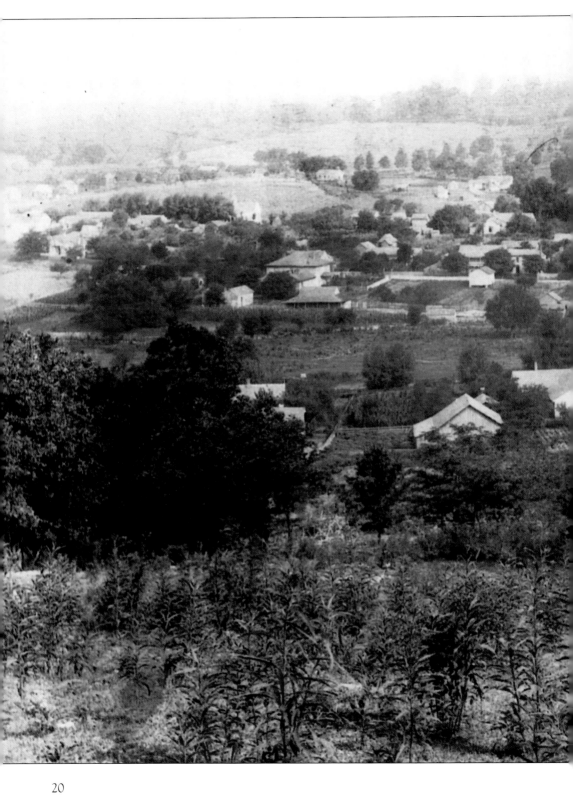

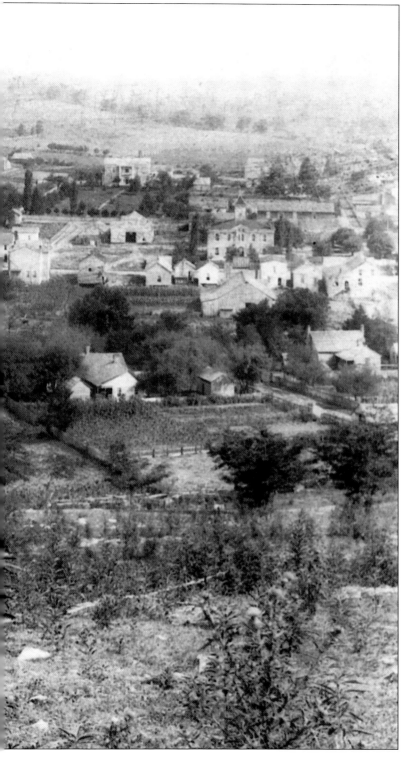

This photograph, believed to have been taken in the mid-1880s, depicts the town of Lynchburg from a nearby hilltop. The line of houses closest in the foreground is historic Mulberry Street, located just behind the buildings on the east side of Lynchburg Square. In the middle right is the Moore County Courthouse (with the steeple), built in 1885. In the right background, the David McCord Hospital (with the pillars), built in 1876, is clearly visible. Also visible (five houses to the left of the courthouse) is the rear portion of the old Moore County Jail, indicating that this photograph was taken after its construction in 1895. Miss Mary Bobo's Boarding House is to the left of the jail. (Courtesy of Buford Jennings.)

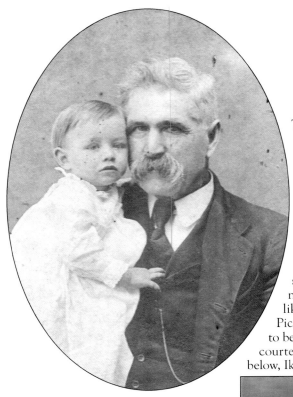

The Farrar family has deep roots in Moore County; however, much of the family resided just over the Bedford County line. Clara Holt, seen below, was born in 1881 and was the daughter of Walton W. Holt, a banker who possessed numerous landholdings in the area, and Susan Victoria Motlow. A family tradition holds that Thurston Farrar, of Flat Creek, drove racehorses, and one day he rounded a corner so fast that his buggy stood on two wheels. Upon seeing this, Walton Holt exclaimed that no daughter of his would ever date a man like that—naturally, Clara married Farrar. Pictured at left is Samuel Haslett, believed to be holding his grandson Wade Farrar. (Left, courtesy of the Moore County Public Library; below, Ike Farrar.)

Isaiah "Ike" Reagor Farrar (seen here as a toddler) was born in 1919 and was the son of Clara Holt and Thurston Farrar. Isaiah's parents married at the Walton W. Holt mansion in Lynchburg, which in 1927 became the local high school. Clara and Thurston were close friends of Senator Reagor and Jeanie Motlow, and Isaiah remembers taking country drives in their automobile. (Courtesy of Ike Farrar.)

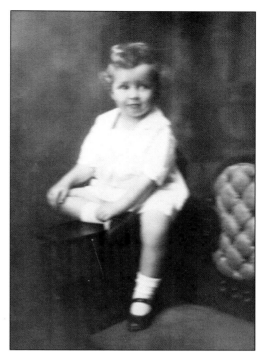

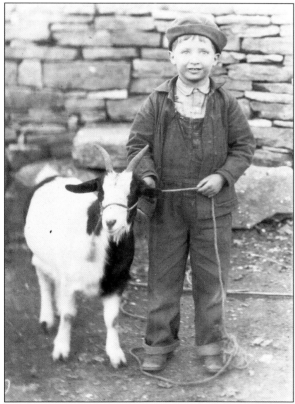

When Clara and Thurston Farrar married, they returned to the Farrar farm in the Flat Creek area for a reception. The family story goes that the weather was so cold the horses had to be shod with cork to tread the sheets of ice along the way. Their son Isaiah is pictured here with the pet goat he used to complete his daily chores, pulling the lawn mower and harrow. (Courtesy of Ike Farrar.)

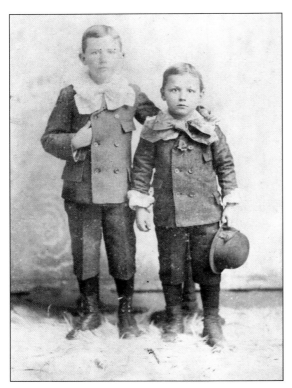

James Jackson Bean (below), the son of Conner and Mary Jean Bean, was born in Marble Hill in 1864. He was a longtime attorney in Lynchburg and served in the state legislature for more than 20 years. Bean was considered an excellent orator and was elected four times as a delegate to the Democratic National Convention. He studied law at the University of Tennessee and was admitted to the bar in 1902. He married Emma Holt, daughter of Walton W. Holt and sister of Clara Holt, on December 19, 1888. They had two sons, Homer J. and Holt Bean (at left); Homer was an attorney in Murfreesboro, Tennessee. (Courtesy of Ike Farrar.)

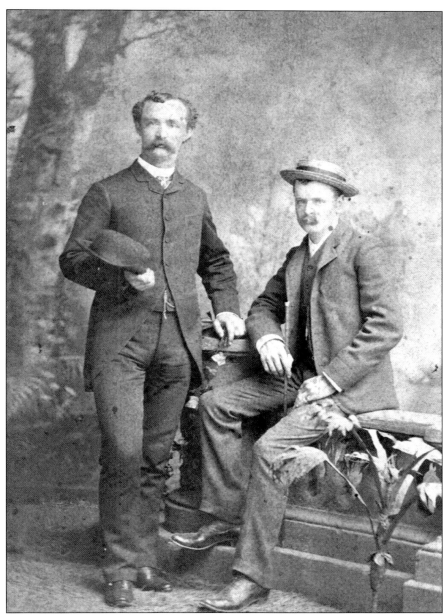

Dr. Stephen E.H. Dance was the son of Stephen M. and Sarah Smith Dance, who wed in Granville County, North Carolina, in December 1813. The Dance family migrated to Lincoln County around 1826. Stephen E.H. Dance studied medicine at the University of Tennessee and graduated from the Louisville Kentucky Medical College in 1856. He returned to Tennessee and began his practice in Lynchburg that same year. In September 1856, Dr. Dance married Miami Berry, and they had eight children. Along with his son Dr. William H.R. Dance, he opened the Dance Drug Store in Lynchburg. During the Civil War, Dr. Stephen Dance served as a surgeon to the First Tennessee Infantry Regiment and the Eighth Tennessee Infantry. He was then named medical director for the Tennessee Reserves. Dr. Dance is named in this photograph but is not identified. (Courtesy of the Moore County Public Library.)

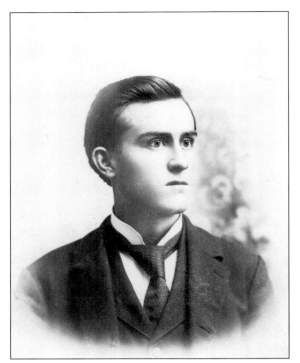

Monroe Green was known as a timber man who had a good team of mules. When the opening of the Farmers Bank was delayed because the safe had become stuck in mud, Green volunteered to deliver it. It took a month, and upon his delivery business began at the bank. (Courtesy of the Moore County Public Library.)

A game of checkers, a popular pastime in the late 19th century, is taking place here in Lynchburg in 1897. The exact location of this photograph is unknown, but it was likely taken outside one of the saloons or general stores on the town square. Joseph C. Martin (seated, second to the right) is the only man identified in the photograph. (Courtesy of Louise Ervin.)

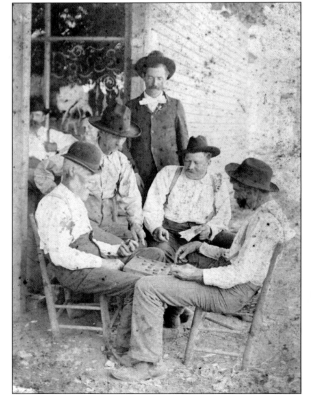

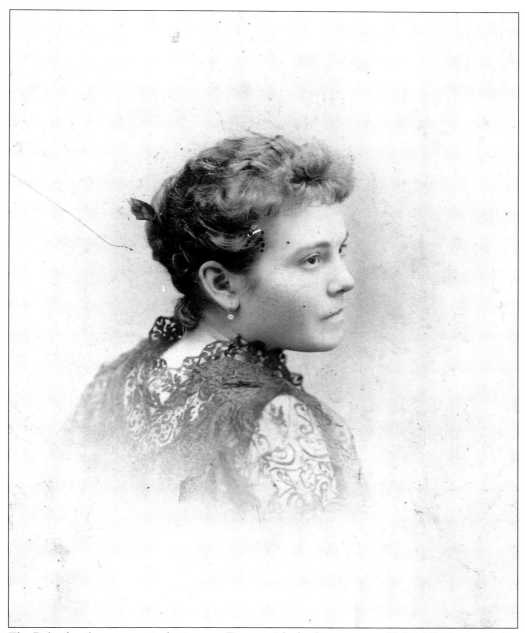

The Bobo family can trace its heritage to France with the first ancestor, Gabriel Baubau, arriving in Virginia in 1700. Around the beginning of the 1800s, Burrell and Elizabeth Bobo migrated to what would become the Moore County area. With their early arrival, the Bobo roots run deep in the area. Nora Bobo Holt Althauser (pictured) was the daughter of Callie Pennington and Thomas Washington Bobo. When Thomas died of influenza, Callie became a widow in her 20s, left alone to raise Nora and three other children. Nora first married James Holt and later wed an Althauser. Nora is remembered as a strong-willed and boisterous woman. She had one daughter, Annie Mary Althauser, who married Phy Wanslow. The two moved to Pecos, Texas, where they operated a hotel. (Courtesy of the Moore County Public Library.)

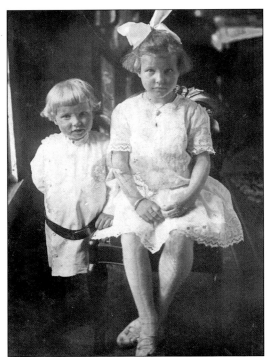

Charles and Louise Bobo (left) were the children of Lacy Jackson and Mary Evans Bobo. Mary was the longtime proprietress of Miss Mary Bobo's Boarding House. She ran her establishment from 1908 until her death in 1983. Louise Bobo Crutcher (below) lived next door to the hotel. (Courtesy of the Moore County Public Library.)

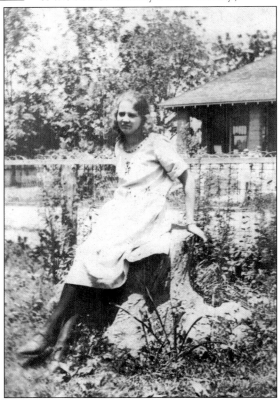

Clarice "Clara" Smith Parks, pictured here around age 16, left Moore County for California. Apparently tired of country life, she left her children by the fire while she hid until her husband arrived home for lunch. Once she knew the children were safe, she left home and never returned. (Courtesy of Annie Lou Tomlin.)

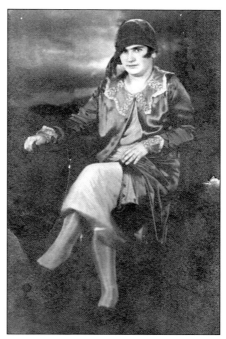

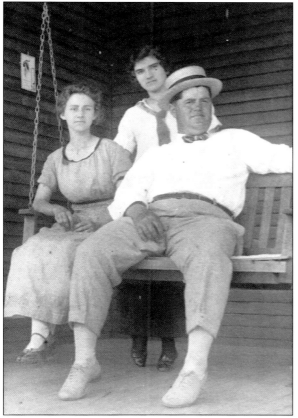

Beginning in 1910, Lynchburg was home to a popular string band. The band performed until the early 1930s and was at times joined by a similar band from neighboring Fayetteville (Lincoln County). Clarence Motlow (right) was an original member of the band. (Courtesy of the Moore County Public Library.)

Although Moore County is a small, rural area, locals have long-held customs involving formal events and social finery. Pictured here are Mary Cheslar of Columbia, Tennessee (left); Wilma Dickey of Lynchburg (center); and Della Willis of Franklin, Tennessee. These ladies posed for a photograph while dressed in some of their best attire on "Ball Night," Friday afternoon, September 3, 1915. The reason for the ball is unknown. (Courtesy of the Moore County Jail Museum.)

Following suit, Edward Burton shows off his stylish clothes in 1923. (Courtesy of the Moore County Jail Museum.)

Lem Motlow, longtime proprietor of the Jack Daniel Distillery, was known as a breeder of fine mules. During the Prohibition years, Motlow expanded his mule-trading business and made Lynchburg the mule capital of the region, if not the country. For about four years, Motlow held large auctions that brought buyers to Moore County from many states. This is an excerpt from a large poster advertising one of Motlow's auctions. He was often known to stage large barbeques during his sales and missed no opportunity to advertise his whiskey. This poster offered a "plentiful supply" of whiskey at the warehouse and promised that "Jack Daniel Whiskey will be poured at The White Rabbit and Red Dog Saloons of Lynchburg." Motlow also advertised Miss Mary Bobo's Boarding House, with a room and bath costing less than $2. (Courtesy of the Iron Kettle Restaurant.)

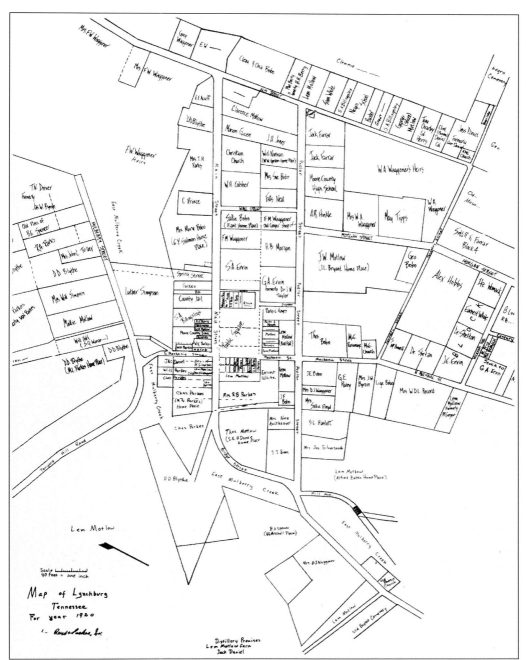

This map of Lynchburg was drawn for the year 1920. Although it had undoubtedly grown, the layout of the town very much resembles its appearance before the beginning of the 20th century. Likewise, Lynchburg has not tremendously changed since the drafting of this map; however, by the time this sketch was executed, the town square had essentially been rebuilt after the great fire of 1913. The fire began at the Dance Drug Store, located on the east side of the square, on July 18, 1913, engulfing and destroying the entire east side and most of the south side, sending numerous businesses and countless merchandise up in smoke. (Courtesy of Louise Ervin.)

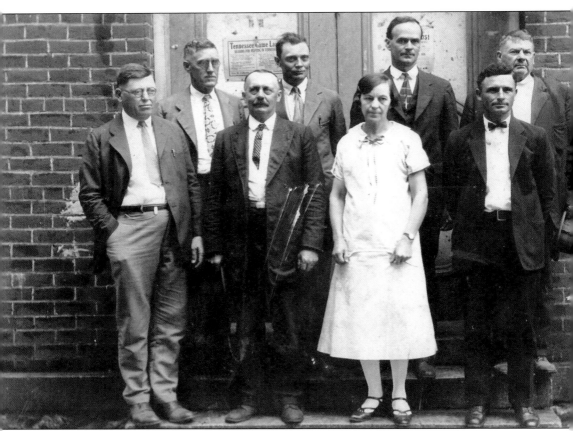

This photograph depicts the Moore County Courthouse staff in 1924. Pictured here are, from left to right, (first row) George Shaw, Chancery court clerk; Alvis Bean, sheriff; Pearl Bobo, register; and Curtis Patton, trustee; (second row) Reuben Setiff, county court chairman; Lannie H. Wiseman, superintendent of schools; Rufus Walter Sweeney, county court clerk; and George Holt, school board. Wiseman was among the group of men who established the Lois Cemetery in 1927. Bean was elected to serve three terms as Moore County sheriff, from 1922 to 1928. Patton served as trustee from 1922 to 1926, and Rufus Sweeney served as county court clerk from 1923 until 1930. (Courtesy of the Moore County Public Library.)

Emma Jane Hinkle Riddle was the daughter of Arthur Rutledge Hinkle and Mary Elon Pattie. The couple married in 1870 and moved to Lynchburg, where Arthur worked as a carpenter. Emma Jane was a member of the Lynchburg String Band that originated in 1910. (Courtesy of the Moore County Public Library.)

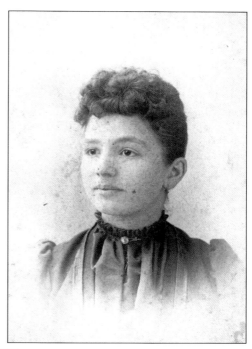

Jack Daniel is Moore County's most famous son. He learned to distill whiskey at an early age and went on to establish an empire that continues to thrive. This statue of Daniel once stood at the mouth of Cave Spring as a reminder of the small man who always made a big impression. (Courtesy of the Jack Daniel Distillery.)

In the late 18th and early 19th centuries, droves of settlers migrated west in search of fortunes to be found in the fresh, fertile soils. Intensive farming had drained Eastern lands of nutrients, leaving both large planters and small yeoman farmers desperate for new income and opportunity. Government-appointed teams of explorers brought back stories of rolling hills and fertile soil to the Eastern Seaboard states, encouraging the attitude of Manifest Destiny. The hundreds of miles covered required extensive equipment and supplies, which cost a lot of money. The journeys were long and arduous, and conflicts with Native Americans made the trips dangerous. Nonetheless, early pioneers like these two men pictured here often risked everything for a chance at a fresh start. For reasons as unique as the people who came here, early settlers like those listed in this chapter came to the Lynchburg area and created a rich and diverse heritage. (Courtesy of the Moore County Public Library.)

Two

Jack Daniel's Tennessee Whiskey

Without question, the Jack Daniel Distillery placed Lynchburg on the map. With his Old No. 7 Tennessee whiskey, Mr. Jack, as he is sentimentally known to the locals, has become world famous for what many consider the best whiskey on the planet. Although the distillery is now a massive enterprise, it and Jack Daniel came from humble beginnings. For someone of his fame and stature, Mr. Jack lived an enigmatic life in many ways. He learned to make whiskey at a very early age and lived his life as a perpetual bachelor. He was a brilliant and cunning businessman, but he was also a constant fixture within the social circles of Lynchburg.

When Daniel passed away, ownership of the distillery operations passed to his nephew Lem Motlow. With the help of his sons, Motlow was able to keep the Jack Daniel Distillery from dissolution during the Prohibition years. Later, during World War II, it is said that the distillery produced alcohol for military operations—particularly for torpedo fuel. Like Mr. Jack before them, the Motlow family never dismissed that sense of civic duty and pride.

Both Lem and his oldest son, Reagor, served as Tennessee state representatives and senators. Reagor was a staunch advocate for public education, and the family helped establish Motlow State Community College just outside of town. Reagor and his wife, Jeannie, established the Moore County Public Library.

In 1956, the Jack Daniel Distillery was sold to Brown-Forman Beverage Worldwide, Inc., and to this day it continues to make generous contributions to the local community. The popularity of Mr. Jack's distillery has not waned, and about 250,000 people visit each year. The Jack Daniel's World Championship Invitational Barbecue attracts at least 20,000 visitors each October.

This chapter explores the rich history of Mr. Jack, his family, and his distilling process. Moreover, it is intended to shed light on the relationship between the community and its most profitable enterprise.

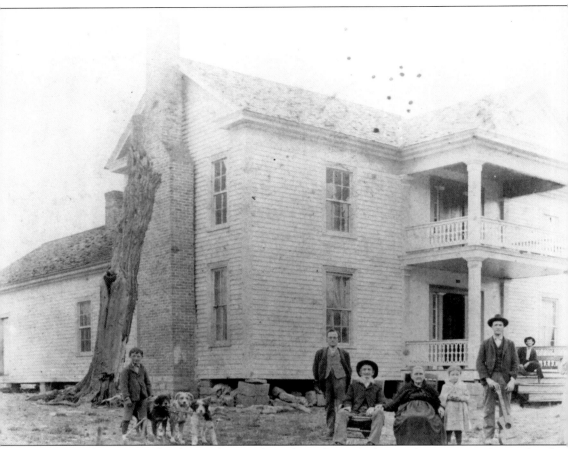

No one knows exactly when Jack Daniel was born; however, his tombstone states September 5, 1856, thus creating the celebrated date. When he was six, he ran away from home to his neighbor Felix Waggoner's house. A year later, he moved in with Daniel "Dan" Call and his wife, Mary Jane. Even though Call's first calling was as a local Lutheran minister, he ran a general store while also distilling whiskey with the help of Uncle Nearest Green, an African American man whom Call believed was the best whiskey distiller around. Daniel was hired to help Call with chores around the house and store, but before long the boy was learning the art of whiskey distillation; he primarily learned this trade from Green. When Daniel was 13, Call decided to leave the distilling business—some say at the urging of his congregation—and Daniel bought the entire operation. Call is pictured here with his family at their home in Mulberry. (Courtesy of the Jack Daniel Distillery.)

Local lore tells that Felix Waggoner urged Jack Daniel to purchase reliable and sturdy transportation in order to sell his product to a larger market. Daniel followed this advice and, along with his friend William Riley "Button" Waggoner, began transporting whiskey to Huntsville, Alabama. During the Civil War, Daniel continued to transport whiskey to Huntsville despite the presence of Union officers along the roads. (Courtesy of the Jack Daniel Distillery.)

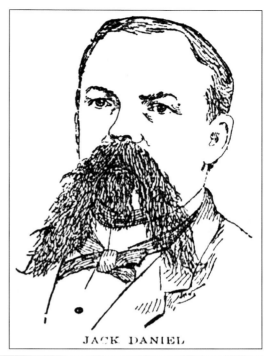

The key to creating the signature taste of Jack Daniel's whiskey, as Daniel discovered, is an abundant supply of clear limestone water. Daniel found his source at Cave Spring, located just off Lynchburg Square. The water at the cave remains a constant 56 degrees and flows at a rate of 800 gallons per minute. This photograph shows the mouth of the cave with a statue of Daniel just outside. (Courtesy of the Jack Daniel Distillery.)

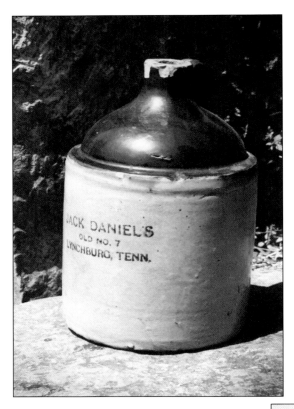

As the Civil War came to a close, Jack Daniel foresaw the possibility of federal regulation and taxation on his whiskey production. In 1866, at around age 16, Daniel officially registered his distillery, making it the first registered distillery in the United States. This image shows an old version of Jack Daniel's packaging. The classic "Old No. 7" clearly appears on the jug. No one knows for sure why Mr. Jack named his whiskey Old No. 7, but the name has stuck. (Courtesy of the Jack Daniel Distillery.)

To demonstrate the progression of the distillery's bottling, this is a bottle from 1895. Although the design had moved away from the earlier jugs, the bottle had not yet been shaped in the iconic style it is currently known for. (Courtesy of the Jack Daniel Distillery.)

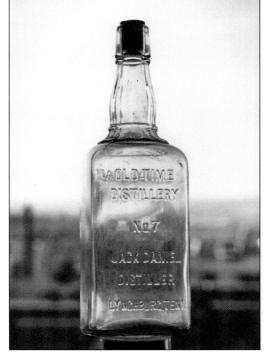

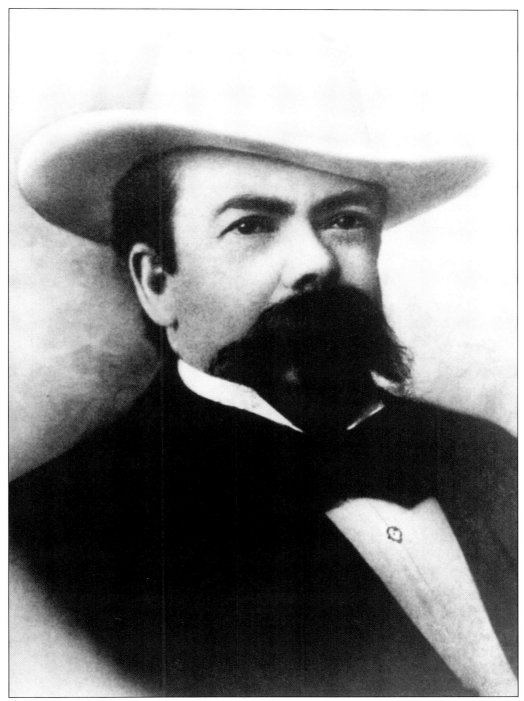

As Jack Daniel's fame and success escalated, he began to form his own personal style. After a day of shopping, Daniel arrived home for the first time in his signature knee-length frock coat and high-rolled planter's hat. Such attire, as seen here, became part of Daniel's iconic image. (Courtesy of the Jack Daniel Distillery.)

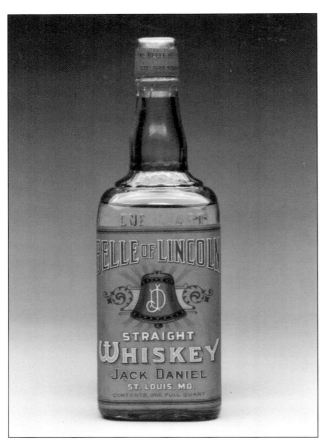

Although he never married, Daniel was no stranger to the ladies. In fact, he named one of his whiskey varieties Belle of Lincoln after one of his pretty companions; however, Mr. Jack never admitted which lady the whiskey was named for. He threw many parties in his home and was ever present in Lynchburg's social scene. (Courtesy of the Jack Daniel Distillery.)

In 1904, Jack Daniel entered his Old No. 7 whiskey in the World's Fair competition in St. Louis, Missouri. He returned home three days later with a gold medal (pictured) for the best whiskey in the world; this was the official debut of Jack Daniel and his Tennessee whiskey on the worldwide stage. (Courtesy of Jack Daniel Distillery.)

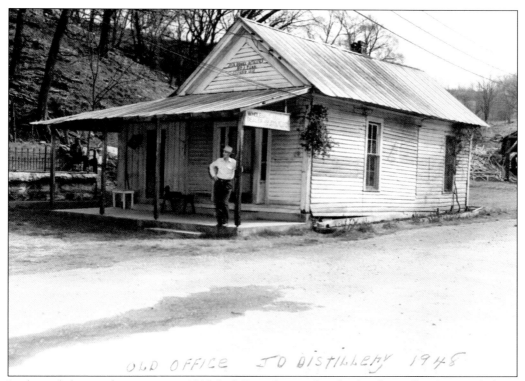

In the early hours of a morning in 1905, Jack Daniel arrived at the distillery office (pictured above in 1948). The story goes that Mr. Jack desired access to the locked safe inside, but he could not retrieve the correct combination. After several unsuccessful attempts, he grew impatient and frustrated, delivering a swift, hard kick to the side of the safe—a move that set his fate. His injured toe led to a serious decline in health, and he suffered with his injury for six years before blood poisoning (local legend states it as gangrene) set in and ultimately resulted in Daniel's death. His grave, pictured below, is in the Lynchburg Cemetery. (Courtesy of the Jack Daniel Distillery.)

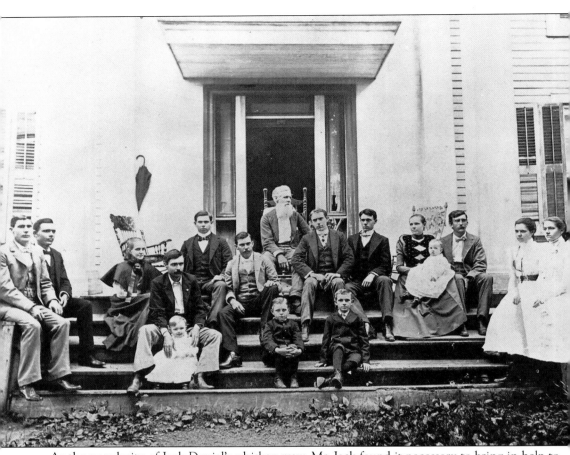

As the popularity of Jack Daniel's whiskey grew, Mr. Jack found it necessary to bring in help to run his expanding operations. His nephew Lem Motlow was to provide Daniel with the assistance he needed. Motlow was the son of Felix "Stump" Motlow and Josephine Finetta Daniel Motlow, Jack Daniel's sister. This photograph of the Felix Motlow family was likely taken around 1900. Lem is visible on the stairs at the front left holding his oldest son, Reagor. Behind him is his first wife, Clara Reagor Motlow. Clara died in 1901, and Reagor was their only child. Lem married Ophelia Evans in 1904, and together they had four more children: Robert Taylor, Dan Evans, Cliff Connor, and Mary Avon. Felix Motlow, the patriarch, is pictured in the back center, and to the right is Thomas (Tom) Motlow. In 1916, Thomas assumed the presidency of the Farmers Bank in Lynchburg, which is still operational today. (Courtesy of the Moore County Public Library.)

Lem Motlow was born in 1869 in Lincoln County. Motlow began working for Jack Daniel in 1887, when he was only 17 years old. The oldest of 10 children, Motlow approached his uncle and requested a job, with the money he made going to support his large family. (Courtesy of Ike Farrar.)

Lem Motlow began his career at the distillery as a farmhand, earning $9 per month. After two years at the distillery, Daniel moved Lem into the office as a bookkeeper. Since he lacked experience, he was taught the trade in the evenings by William "Bill" Hughes, the head distiller at the time. Eventually, Motlow became the longtime proprietor of the distillery. (Courtesy of the Jack Daniel Distillery.)

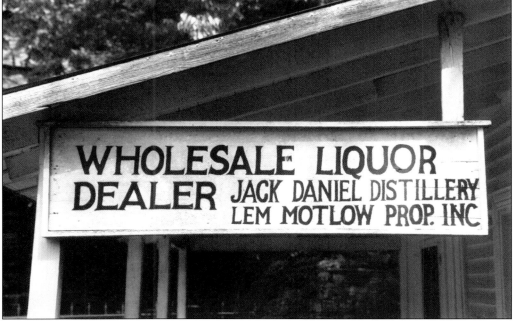

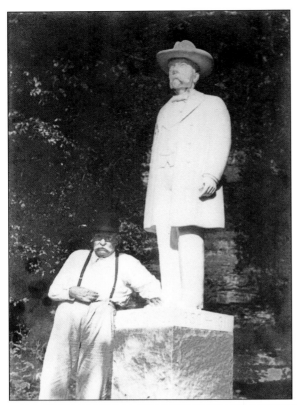

When Lem Motlow took over operations at the distillery in 1907, the Prohibition movement was sweeping the country. As Tennessee banned liquor production statewide, Motlow moved the distillery's operation to St. Louis, Missouri, in 1910. His St. Louis warehouse was robbed in 1923 by professional gangsters, reportedly working under Al Capone, who stole some 42,000 gallons of whiskey. (Courtesy of the Moore County Public Library.)

This may be one of the only surviving images of Jack Daniel's house. Pictured is one of Daniel's horses, and seated on the porch is James "Jimmy" Conner, Daniel's brother-in-law; the man in the foreground is unidentified. Lem Motlow was also a first-class horse breeder. (Courtesy of the Moore County Public Library.)

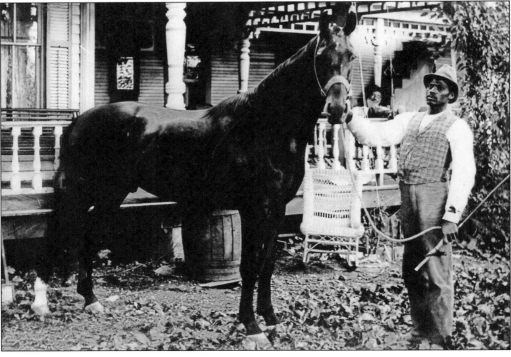

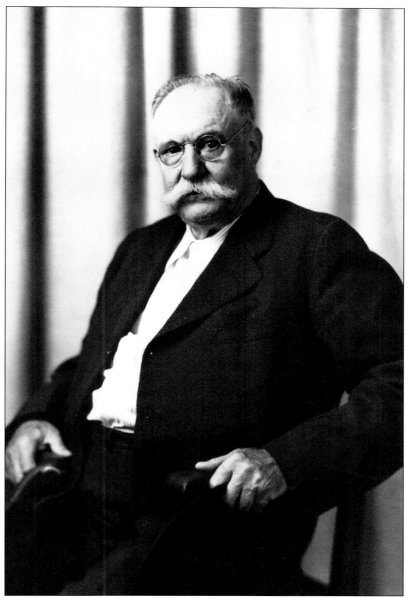
When the 21st Amendment to the Constitution repealed federal Prohibition in 1933, Jack Daniel Distillery remained inactive. Tennessee still enforced its Prohibition laws, preventing the production of alcohol. As a Tennessee state senator, Lem Motlow worked to repeal these laws, and the production of whiskey was permitted to resume in Lynchburg in 1938; however, the law did not allow the distillery to sell whiskey within the state. Motlow quickly returned to begin rebuilding the distillery and business, disregarding fears of the Great Depression and rumors of World War II. In 1901, Lem and Franklin "Spoon" Motlow bought out the majority shares of the Farmers Bank in Lynchburg, establishing a dynasty for the Motlow family in the banking business. Throughout his career as distiller, banker, businessman, and senator, Motlow continued his farm operations and used his business sense to create a lucrative mule-trading business. Lem Motlow died on September 1, 1947. (Courtesy of the Jack Daniel Distillery.)

John Reagor Motlow, known as Reagor, was born on February 15, 1898, and was the only son of Lem and Clara Motlow. He attended school in Lynchburg and Branham and at Hughes Academy in Spring Hill, Tennessee. Motlow received his bachelor of science degree from Vanderbilt University in 1919. He served as the vice president of Jack Daniel Distillery from 1937 to 1947 and as president from 1947 until 1964. Like his father, Reagor served many years in the Tennessee State Legislature. He was a state representative from 1941 to 1943 and 1947 to 1963 and a state senator from 1965 to 1971. During Prohibition, Motlow ran a flour mill in the inoperative Jack Daniel Distillery in an attempt to keep the building in use. In 1927, the distillery building caught fire while Lem and Reagor were in St. Louis. The cause of the fire was traced to the third floor of the mill—the result of a dust pocket. Reagor died on March 12, 1978. (Courtesy of the Moore County Public Library.)

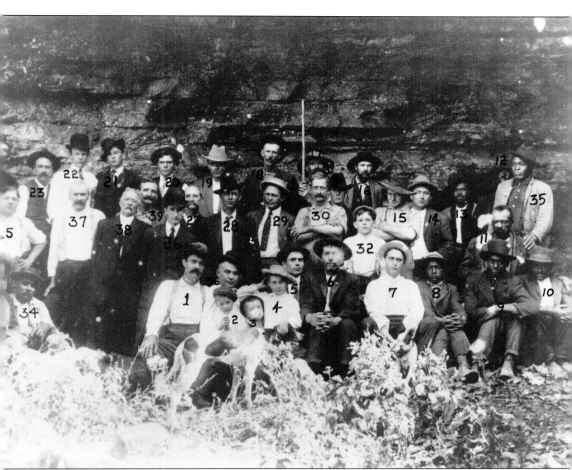

The Jack Daniel Distillery Teamsters are said to have been among the best in the business. They drove a wagon team of six mules and could maneuver through a gate with a mere foot of clearance on each side. It is remembered that the mule team wore dyed cow's-tail tassels, and their harnesses featured shiny brass. Pictured here at Cave Spring, on the grounds of Jack Daniel Distillery, the Teamsters are seen along with several members of the Motlow family, distillery employees, and family friends. The Teamsters were all African American men and are identified by number. At far left is Andy Tolley (33); the remaining Teamsters are grouped at right and are identified as Ott Green (8), Charlie Green (9), Eli Green (11), Gil Savior (13), and Uncle William "Bill" Crutcher (12). Henry Baxter (10) was a handyman, and ? Waggoner (35) has no identified position. (Courtesy of the Moore County Public Library.)

Looking down from a nearby hilltop, this photograph depicts the "rickyard" and surrounding area, including a large warehouse on the next hill. Jack Daniel's whiskey has a distinctive flavor and quality, traits attributed to the now famous Lincoln County process. This distilling method is said to have been created by Alfred Eaton before the Civil War but has become synonymous with Jack Daniel. What distinguishes whiskey produced by this process is that the impurities are removed by filtering the whiskey through charcoal. Jack Daniel's whiskey is only manufactured using charcoal made from sugar maples, and the rickyard is where the sugar maple wood is burned to create charcoal. This location is also the first stop on the present-day distillery tour, which emphasizes its importance in the distilling process. (Courtesy of the Moore County Public Library.)

Logs of sugar maple are brought to the distillery grounds on a regular basis. In keeping with tradition, the Jack Daniel Distillery claims to only use trees from Tennessee suppliers. In the photograph above, entire logs are shown just before being taken into the mill for processing. At right, distillery employee Herman Branch saws the logs into planks. These planks are then stacked into "ricks" and burned. These ricks of sugar maple create the charcoal used in filtering the whiskey. Inside the distillery, copper stills are used for further removal of impurities. (Courtesy of the Moore County Public Library.)

It takes two to three hours for the ricks to burn. In this photograph, a woman sprays water on the remnants of a rick. Jack Daniel's whiskey is often mistaken for bourbon; this is incorrect. The Lincoln County Process, recognized by the federal government as distinctive from those used to make bourbons and other whiskey varieties, is what makes it a Tennessee whiskey. (Courtesy of the Moore County Public Library.)

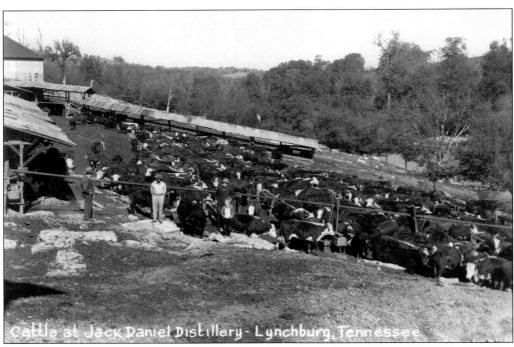

The grounds of the Jack Daniel Distillery were also used for farming operations. The distilling process produces large quantities of a by-product locally known as "slop," which is used to feed livestock. Although the distillery does not currently farm on the grounds, it continues to provide slop to local farmers. (Courtesy of the Moore County Public Library.)

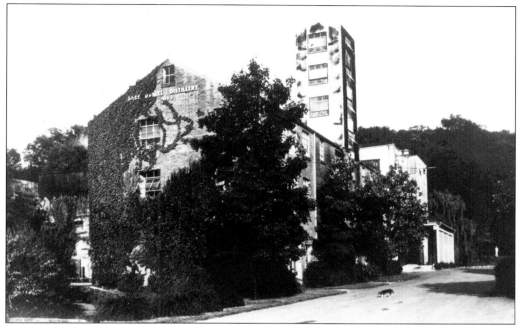

Although the distillery has expanded to include numerous warehouses and an additional bottling house south of town, the main portions located in "the Hollow" around Cave Spring have changed little since the 1930s. On April 9, 1930, the Jack Daniel Distillery was devastated by fire. At the time, Reagor Motlow was utilizing the distillery buildings as a flour mill, and it is believed that the combustion of flour dust caused the fire. A bucket brigade was able to save the warehouse and records of the mill; however, the remainder of the distillery was destroyed, with damages estimated at $25,000 or more. Nonetheless, Lem Motlow rebuilt his distillery and operations resumed in 1937. (Above, courtesy of the Jack Daniel Distillery; below, the Moore County Public Library.)

This photograph shows Jack Daniel's barrels being transported by truck on Distillery Lane. Jack Daniel's Tennessee Whiskey is aged using only freshly charred white oak barrels. No barrel is used more than once. Today, the distillery uses over 5,000 barrels a week, and the old barrelhouse contains 6,059 barrels; additional warehouses dotting the local landscape hold thousands more. (Courtesy of the Jack Daniel Distillery.)

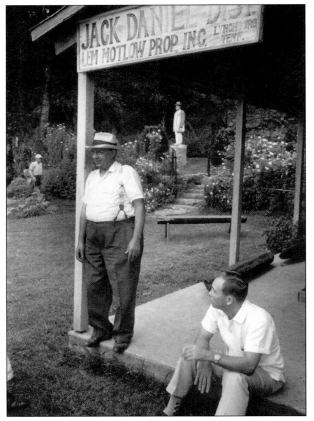

With its incorporation, the distillery was officially named Jack Daniel Distillery, Lem Motlow, Prop., Inc. Every bottle bore that name, along with "Population 361," until 2011, when the Brown-Ferman Corporation decided to remove the famous lines in an effort to streamline the labeling. (Courtesy of the Moore County Public Library.)

Jeff Arnett was named Jack Daniel's master distiller in 2008. He is only the seventh master distiller in the company's 142-year history. Daniel himself held the title from 1866 to 1911 and Jess Motlow followed from 1911 to 1941. Lem Tolley took the prestigious position in 1941 and held it until 1964, followed by Jess Gamble from 1964 to 1966. In more recent years, the title belonged to Frank Bobo from 1966 until 1992 and Jimmy Bedford from 1992 until 2008. The master distiller oversees and manages every aspect of making Jack Daniel's whiskey, from the milling of the sugar maple to the full maturation in the white oak barrels. The job is no light task, and the company continues to uphold Daniel's motto: "Every day we make it, we'll make it the best we can." (Courtesy of the Jack Daniel Distillery.)

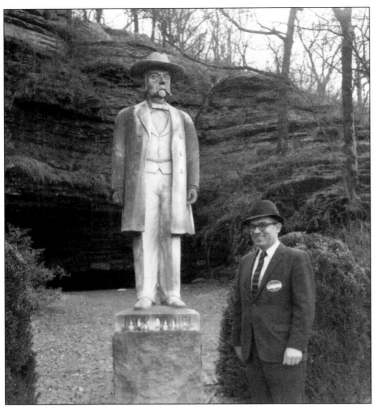

This famous statue of Jack Daniel was originally placed in front of Cave Spring in 1941 and has since been an iconic image. The distillery has offered daily tours of its operations for many years, and each tour group has a photograph made; the image below was taken in the 1980s. The original statue was deemed ill prepared to weather the outdoors and was moved into the visitor center in 2001. A bronze statue now stands outside of Cave Spring, and tour groups have a photograph taken at the rickyard. (Left, courtesy of Moore County Public Library; below, Annie Lou Tomlin.)

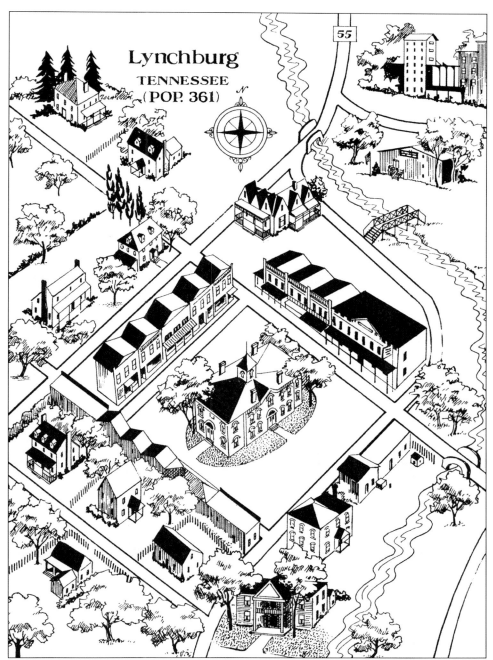

This ink drawing by an unidentified artist depicts the Jack Daniel's facility in Lynchburg and its proximity to the town square. The date of the drawing is unknown; the absence of the distillery's visitor center suggests it was completed before 2001. While many of the local buildings are rather accurately depicted, it is interesting to note that Lem Motlow's house, which still stands today, is not represented. Nonetheless, the aerial viewpoint of the picture provides the reader with a bird's-eye view of Mulberry Creek and its directional flow. (Courtesy of the Moore County Public Library.)

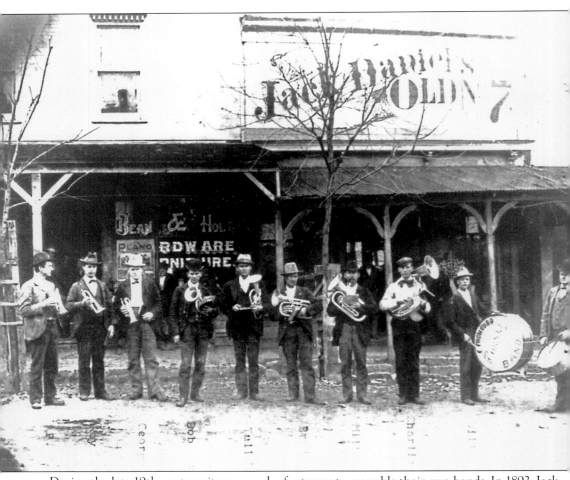

During the late 19th century, it was popular for towns to assemble their own bands. In 1892, Jack Daniel did exactly that, creating the Silver Cornet Band. He ordered instruments from the Sears and Roebuck catalog, spending about $300 to outfit the 13 musicians. Once the instruments arrived, he had a side of the drum painted with "Jack Daniel's Old No. 7," as he was a constant advocate and salesman of his product. The original band members were locals with very little musical training, but the band was much admired. The original Silver Cornet Band disbanded with the onset of World War I, as many of its members joined the war effort. The distillery continues its involvement with music; in 2011, for example, Jack Daniel's partnered with the Grammy Award–winning Zac Brown Band. (Courtesy of the Jack Daniel Distillery.)

Three
SCHOOLS

Education has long been a priority of Moore Countians. Although the earliest settlers were typically left to educate their own children, often by meager means, in the early days a few teachers set up and taught in private subscription schools. By the 1880s, schools were in operation in the Lynchburg, Marble Hill, County Line, and Ridgeville communities. Smaller academies were eventually established, and the state later established a meager yet functional public school system; however, this system did not offer free public schooling as it is known today.

As a farming community, the need to tend to agricultural undertakings took priority over scholastic duties during varying parts of the year; therefore, children did not typically attend school year-round. At first, the county provided the funds required for attendance during the three-month fall term. However, enrollment for the spring term carried a tuition fee of $1 per month to be paid by the student's family. Not surprisingly, many people opted not to send their children to school during the spring months, which coincided with the planting season.

African American children in the county, although segregated, received the opportunity for education as well, but the opportunity for public education only came at the turn of the 20th century. At least four schools served the needs of the local black community: Gum Springs, established in the 1920s; Lynchburg and Porter, both established between 1900 and 1910; and the Highview School, which was the last remaining all-black school. Although little information and presumably no photographs remain as testament to some of the African American schools, what survives adds yet another layer to the history of Moore County and the efforts by its citizens—both black and white—to provide children with the best education possible.

The educational histories of both Lynchburg and rural Moore County are explored in the following pages, along with the community's affinity for sports and recreation.

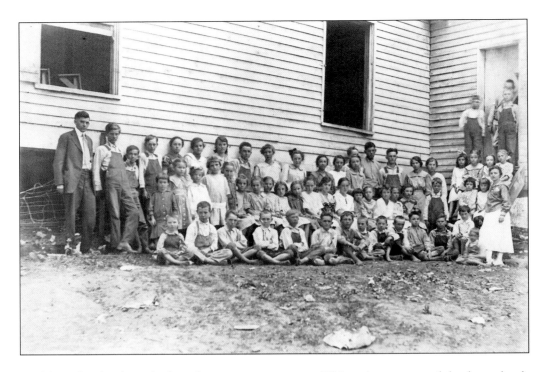

Marble Hill School was built and in operation prior to 1886, making it one of the first schools established in the early county. The school was located on the P.O. Harrison farm. In the 1915 photograph above, teachers include Jess Nunley (back left) and his wife (front right), while below in 1919 are teacher Lois Hobbs (back left) and a class of children. In 1925, the school employed two teachers, Georgia Gray and Essie Faulkner, both of whom had finished four years of high school. Both ladies earned fair incomes of $90 and $65 per month, respectively. Students attended the school until the late 1930s. (Courtesy of the Moore County Public Library.)

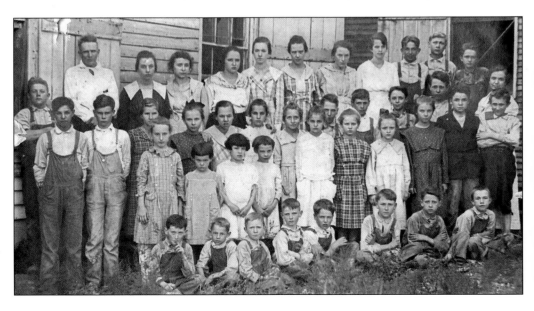

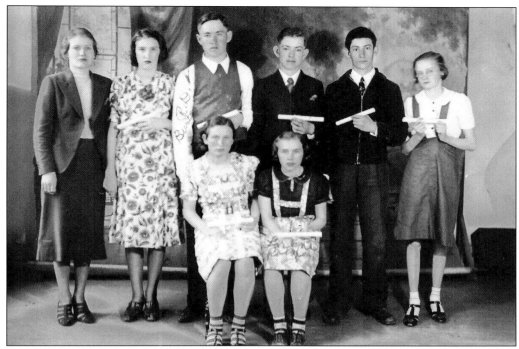

The Ridgeville School was located on a half-acre lot. The school was built before 1886, making it one of the earliest established schools in the county. Reportedly, the grounds were worth an estimated $25, while the one-room frame building and the stove used as a heat source were valued at $350. Since the building lacked internal plumbing, drinking water was provided by a spring, which was not located on school grounds. The 1915 image above shows the eighth-grade graduating class and its teacher, Jewell M. Spencer. Below, students in Spencer's 1938 class enjoy a field trip to the Flintville Fish Hatchery, located in neighboring Lincoln County. (Courtesy of the Moore County Public Library.)

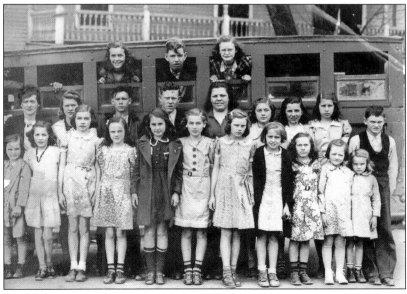

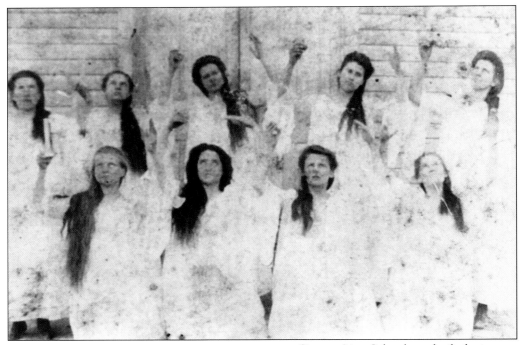

County Line School was built during the early 20th century. By about 1902, attendance at the school was 115 students, with four teachers, including one music instructor. This undated photograph was taken at a student program. (Courtesy of the Moore County Public Library.)

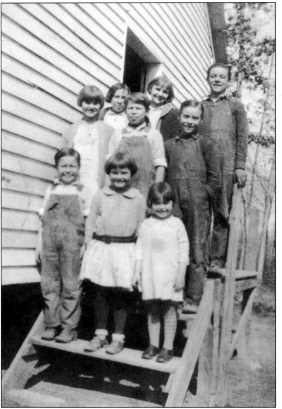

Raysville School, located in rural Moore County, is pictured here in 1929. Daily attendance was reportedly below the required average, yet Raysville School was permitted to remain in operation. Mamie Brown Cashion (not pictured) was the teacher at Raysville in 1929. Raysville was Cashion's first teaching appointment, and she received $55 per month as a salary. (Courtesy of the Moore County Public Library.)

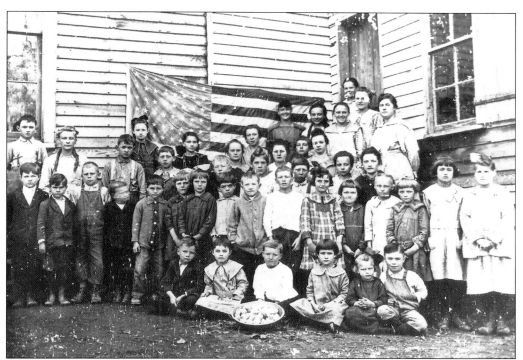

Originally constructed around 1887, the Lois School was first known as Union Hill Academy. The one-room school, shown below in 1904, was built on land donated by Dan Call not far from where Jack Daniel learned to make whiskey. In the beginning, only elementary subjects were taught here; however, high school subjects were also eventually offered. By 1939, the schoolhouse consisted of two rooms. In the 1920 photograph above, the appearance of the school indicates that the second room had likely been constructed by that time. In later years, the school served various purposes outside academia. During World War II, for example, the building was used as a site for young men to register for the draft. (Courtesy of the Moore County Public Library.)

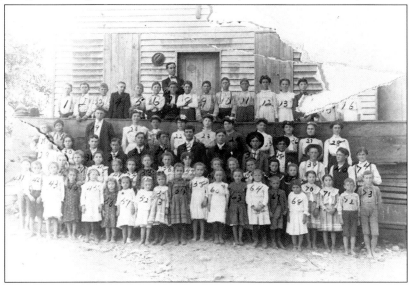

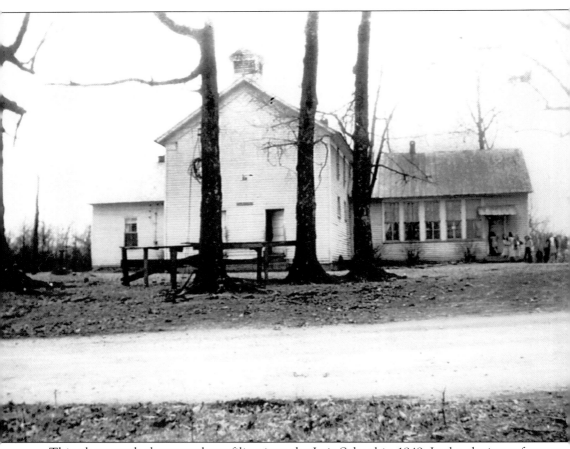

This photograph shows students filing into the Lois School in 1949. It also depicts a famous attribute of the fondly remembered school. It was during this time that the "pecan incident," as it is remembered by those in attendance, occurred. The story goes that someone brought a bag of pecans to school, and some of the children decided they could get away with indulging themselves. So, in a collaborative effort, it was decided that Annie Lou Frame would climb inside the window and retrieve a share of the pecans. She made it in, but was caught, and the plan was foiled. Needless to say, punishments ensued, and the gang of bandits was deterred from committing future crimes. At the far left is the window that Frame utilized to sneak in and steal the much-desired treats. (Courtesy of Annie Lou Frame Tomlin.)

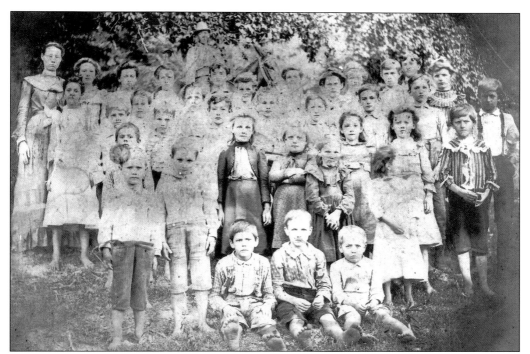

The photograph above shows the students of Spencer Academy in 1904. The back of this photograph states, "Masonic Lodge started meeting in Lois," indicating that perhaps the school building was the site of these meetings. The house that later became Spencer Academy, pictured below, belonged to "Parson" James Simmons Ervin Jr. Ervin was born in 1832 and died in 1910, and the photograph below was taken at his birthday party. A brief anecdote on the back of the photograph tells that one of the young girls in attendance, Miss Hicks, "had on a pretty, new dress. She walked around saying, 'Isn't it pretty?'" (Courtesy of the Moore County Jail Museum.)

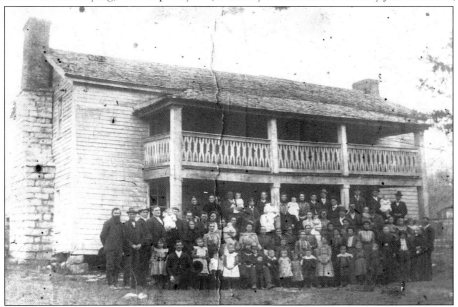

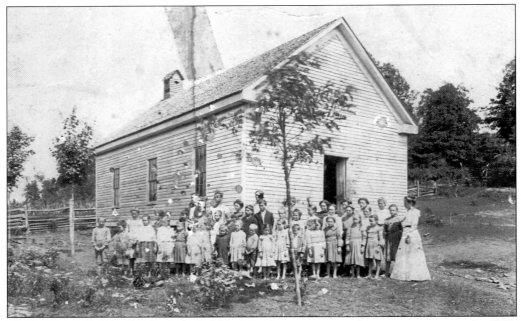

The Sunny Hill School, pictured in 1897, was a frame structure that was in operation by 1889. Irene Prince Cunningham was the teacher in 1897. Between 1902 and 1904, all eight grades were taught by Nora Bobo. During the early years of the 20th century, teachers' salaries were raised from $25 to $27.50. (Courtesy of the Moore County Jail Museum.)

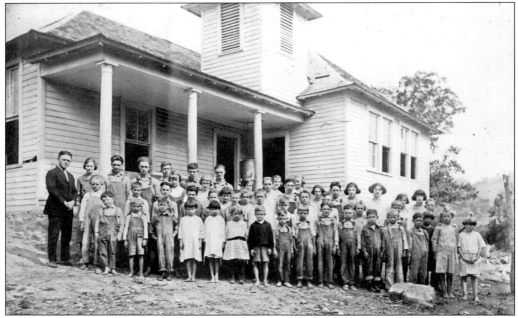

The Charity School was located on "Billy Goat Hill." The school was likely built in the early 20th century and is pictured here in 1923 along with principal Homer Laws and teacher Marie Hobbs. Recollections from the 1930s reveal that the school had no playground, and children were permitted to descend the hill to play ball in a neighboring field. (Courtesy of Louise Ervin.)

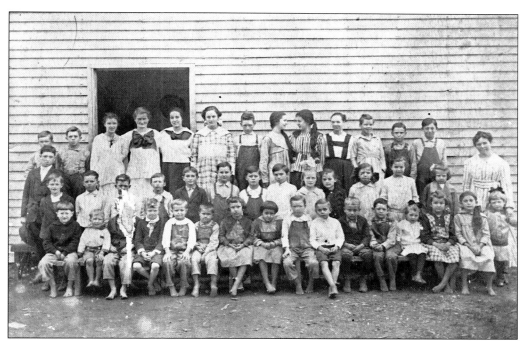

The Pleasant Hill School was located about one mile north of the Hurdlow community and just below Lois. Pictured above in 1918, it is apparent that the building was of a wooden frame construction and most likely consisted of one room. The school's teacher, Lema Mann, is pictured on the far right. Mann died in 1980 at the age of 96. Below, the children of Pleasant Hill School pose for a group photograph in 1919. To the far right stands a young boy whose attire, consisting of a satchel and a military-style jacket, suggests an interest in and perhaps admiration for the American soldiers of World War I. (Courtesy of Louise Ervin.)

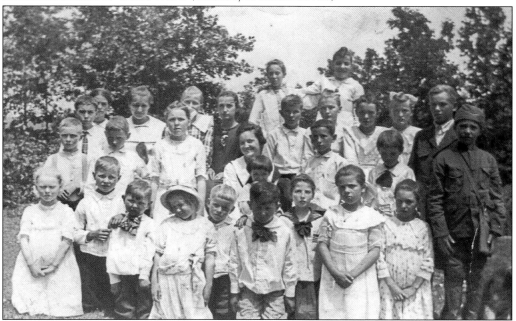

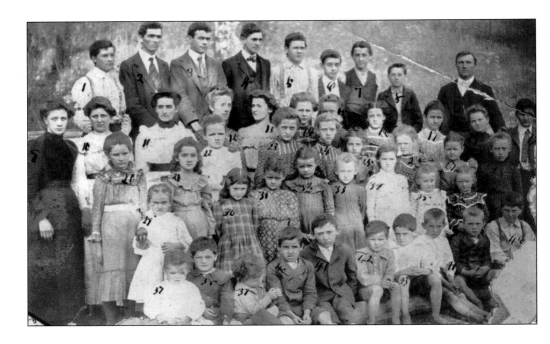

Located close to the Pleasant Hill School, the Fuga School was located on a triangular piece of land along Dry Prong and Farris Creek Roads. The construction date of the Fuga School is unknown; however, the photograph above, taken in 1902, is the earliest found to date. Along with a blacksmith shop and store, the school helped form a thriving community. Recollections from the 1940s describe the school as a white frame building, which is visible below in a 1910 photograph. The school grounds contained separate outhouses for boys and girls. Older boys carried water to the school from a spring on the neighboring Snow farm. (Courtesy of Louise Ervin.)

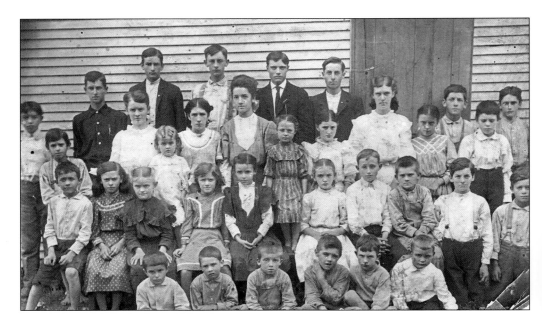

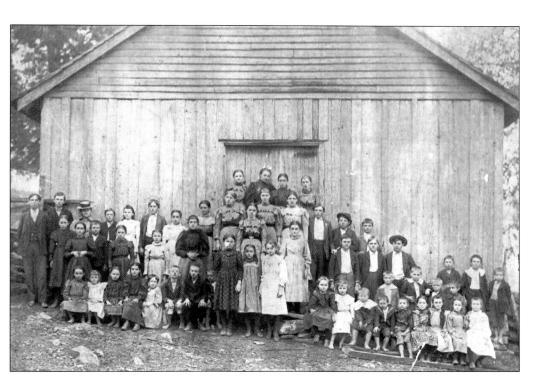

The original Buckeye School building is believed to have been constructed around 1875 and consisted of two rooms. The 1906 image below shows students of the Buckeye School. The vertical wall slats of the frame building, visible in the above photograph, bear remarkable resemblance to the exterior walls of the schoolhouse pictured below. It is likely, therefore, that the image above was also taken around 1906, as a new building was constructed in 1909 with horizontal exterior boards. The school stood on a quarter-acre lot, and drinking water was brought in from a site off of school grounds. (Above, courtesy of Louise Ervin; below, Moore County Public Library.)

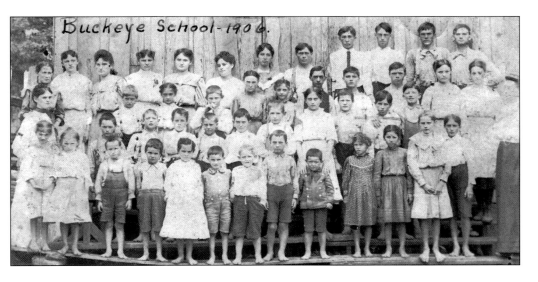

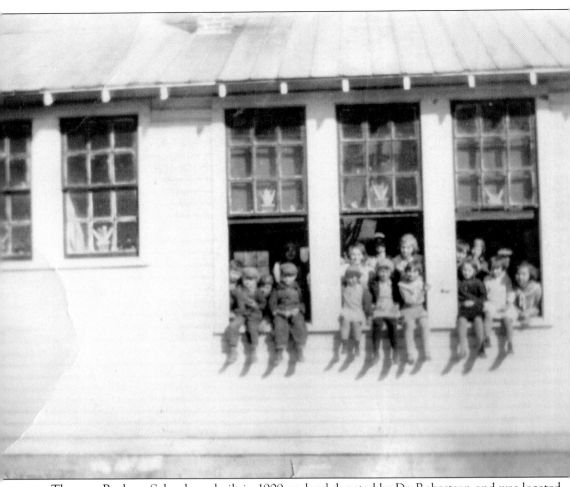

The new Buckeye School was built in 1909 on land donated by Dr. Robertson and was located close to the original two-room schoolhouse. The school did not have a playground, and it stood at the edge of the road. Here, students pose in the windows of the post-1909 building. By 1923, total enrollment at the school consisted of only 16 students, and the teacher was Katie Ruth Ervin. During her tenure, she earned $65 per month for an eight-month term. By 1925, the teaching position belonged to Verna Burrow, who earned $60 per month as salary. Both teachers taught all eight grades at the Buckeye School. (Courtesy of the Moore County Public Library.)

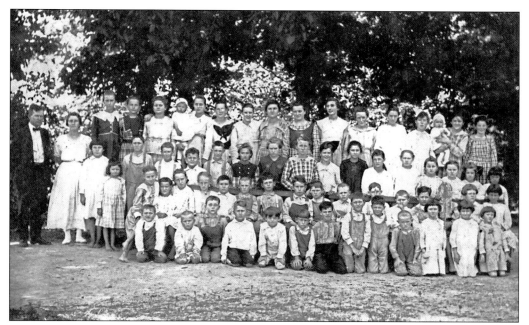

Students of the Liberty Hill School are pictured here in 1918, along with teachers Harris and Gladys Sanders. The construction date of the schoolhouse is unknown, but it was located on a half-acre lot. By 1923, total enrollment for the school reached 99 students. (Courtesy of the Moore County Public Library.)

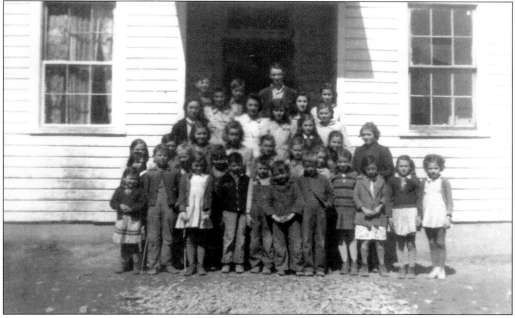

Students pose in front of the second Hickory Hill School in 1933. At this time, Jewell Spencer was teaching all eight grades. The original Hickory Hill School was built in 1890 on land donated by Alexander Husky. Before the first school closed in 1927, plans were underway to build the subsequent school on land donated by Collis Marshal. (Courtesy of the Moore County Public Library.)

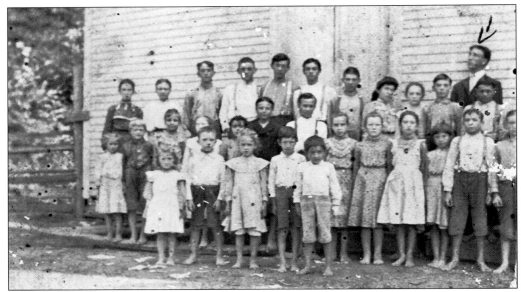

The Hurricane School, pictured here in 1910, was a wooden frame structure and likely consisted of one or two rooms. At the time of this photograph, Ella Daniel was a teacher. By 1925, the teaching position was held by Albert Byrom, who earned $75 per month as salary. (Courtesy of the Moore County Public Library.)

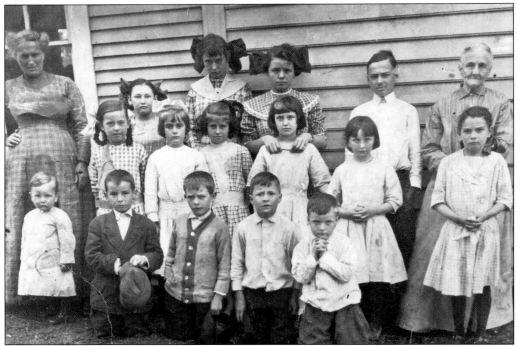

Students at Mollie Boone's private school are pictured here in 1912. Boone was the sister of W.W. Gordon, the editor of the *Lynchburg Falcon*, which was established in 1884. The *Falcon* eventually became the *Moore County News* and is still published today. Boone is pictured on the far right. (Courtesy of the Moore County Public Library.)

Although it was not the first school in Lynchburg dedicated to the education of African American children, Highview School was established in 1928. Originally a one-room building, the school expanded in 1950. Integration began in 1964, marking the year of the school's final graduating class. Once integration was complete, the Highview School was used only for kindergarten and first-grade classes. (Courtesy of the Moore County Public Library.)

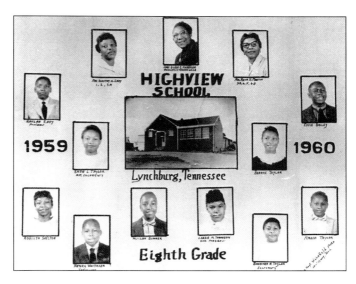

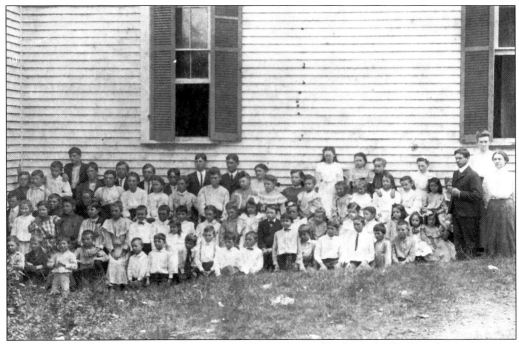

The elementary school at Lynchburg, one of the earliest schools established in the county, was in operation by 1886. This 1909 photograph shows the Lynchburg Elementary elocution class, which taught students the art of public speaking. This training included an emphasis not only on grammar and pronunciation but also gestures and vocal production. (Courtesy of the Moore County Public Library.)

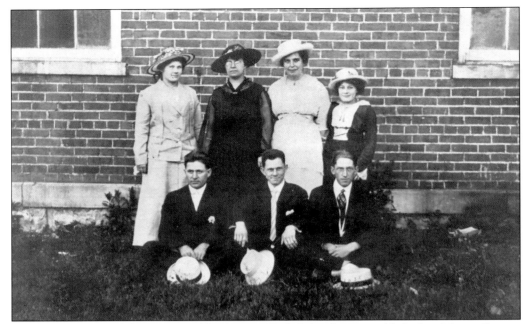

The first high school, known as Public County High School, was established in Moore County in 1914. This c. 1915 image shows the inaugural faculty of the school. They are, from left to right, (first row) N.T. Royster, Frank L. Teuton, and Hollis Williams; (second row) Blanch Poplin, Ethel Blanton, Mary Helmick, and Alma Womack. (Courtesy of the Moore County Public Library.)

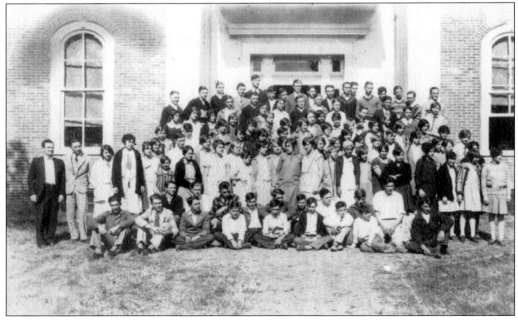

In 1927, the Moore County High School was moved into the Classical-style mansion of Walton W. Holt. Here, the initial 1927–1928 student body is pictured in front of the newly established school. The building was bordered by Church, Poplar, and Magnolia Streets and remained in use until a new school was built in 1932. (Courtesy of the Moore County Public Library.)

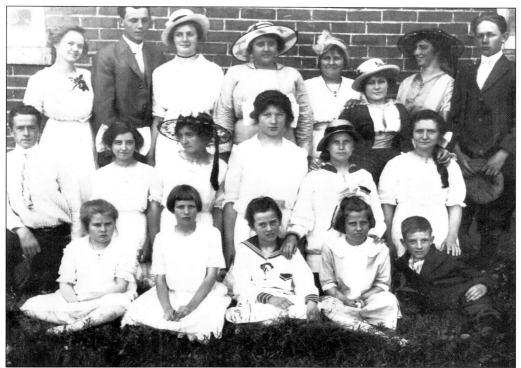

Music has a long and proud history in Moore County. Alma Womack, a member of Public High School's initial faculty, is pictured above with her 1914–1915 music class. The first instrument donated to the Moore County High School Band was the tuba shown in the image below, which was given to the school by Woodmen of the World, a fraternal insurance organization, at an unknown date. The first dollar donated toward the school band is visible at the bottom of the glass case. (Courtesy of the Moore County Public Library.)

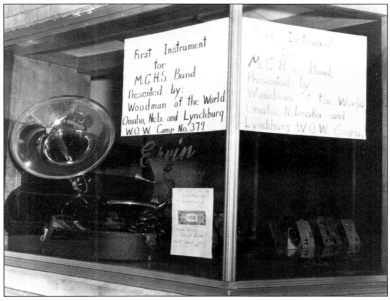

In 1931, a new school was under construction at the end of Mechanic Street. In this building, the grade school and high school were combined, and the grade-school classes consisted of two grades in a single room. The land upon which the school was built belonged to Dr. McCord, and the original structure has since been torn down and rebuilt. The site is currently home to the Lynchburg Elementary School. The classes shown here were among the last to attend the old elementary school. The 1931 image on the left is of the first- and second-grade classes, while below are the third- and fourth-grade classes of 1930–1931. (Courtesy of the Moore County Public Library.)

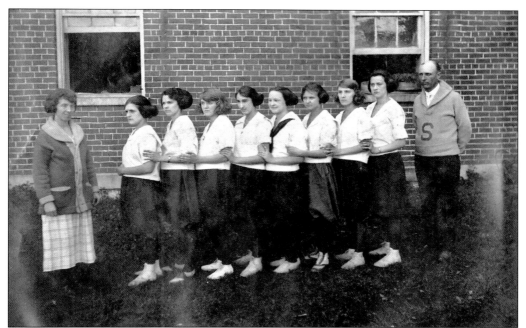

Student athletics has a long and proud history in Moore County. The c. 1919 photograph above shows the first girls' basketball team at Moore County High School. Those who can be identified in the image are Hazel Silvertooth, Mary B. Moore, Lara Waggoner, Mary Agnes Ervin, Floy Bobo, Bernice Waggoner, Wanda Bobo, and ? Bratton (principal). In stark contrast to the first team, the 1950 girls' team is pictured below. Pictured are, from left to right, Dorris Bennett, Jo Edde, Jewel Raby, Jane Bartlett, Betty Robertson, Betty Biggs, Betty Bennett, Joan White, Fay Parks, Bobbie Jane Tipps, Iris Laten, Nina Jean Tolley, Anita Millsap, and Pecola Laten. (Courtesy of the Moore County Public Library.)

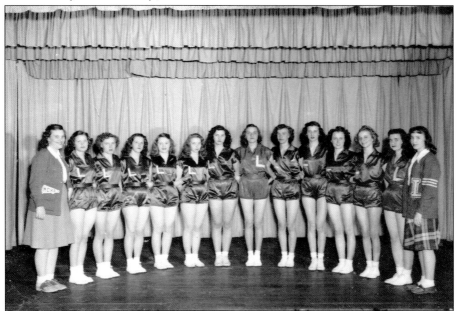

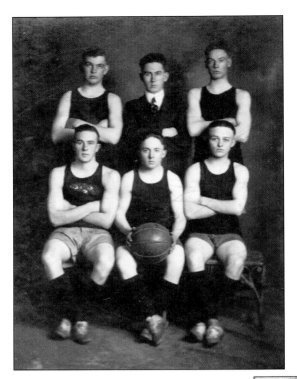

Basketball teams at Moore County High School predate football teams by about two years, with the first football team established in 1922. This photograph was likely taken in the early 1920s. (Courtesy of the Moore County Public Library.)

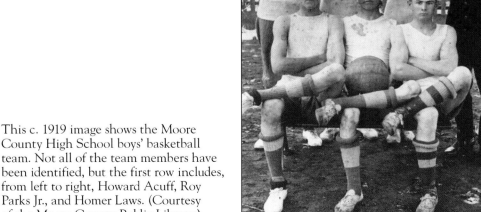

This c. 1919 image shows the Moore County High School boys' basketball team. Not all of the team members have been identified, but the first row includes, from left to right, Howard Acuff, Roy Parks Jr., and Homer Laws. (Courtesy of the Moore County Public Library.)

This c. 1915 photograph is identified only as a school group, but it may possibly be the five members of the Moore County High School boys' basketball team. Pictured are, from left to right, (first row) Collis Woodard and Gordon Holt; (second row) George Gore, Cliff Parks, and Lulan Dance. (Courtesy of the Moore County Public Library.)

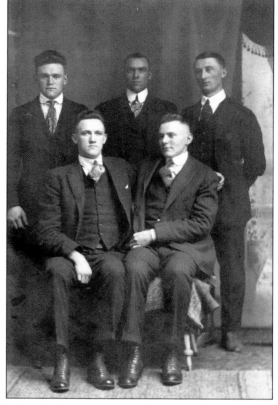

A 1922 photograph shows the first Moore County High School football team. Pictured are, from left to right, David Rochelle, Marvin Bobo, Ott Spann, Fred Woosley, Paul Setliff, Charlie Bedford, Earl Bobo, Hollis Price, Ray Parkes, Lyndon Simpson, Robert Dance, Ollie Moore Prince, John Stone, Homer Robertson, and coach Wilburn Rochelle. (Courtesy of the Moore County Public Library.)

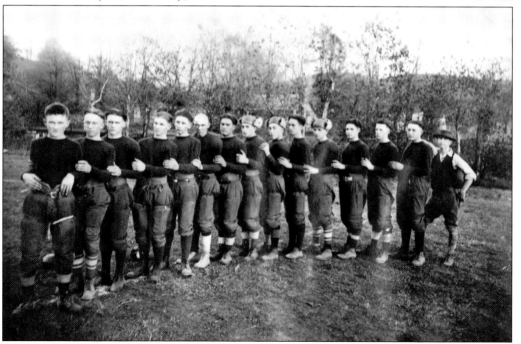

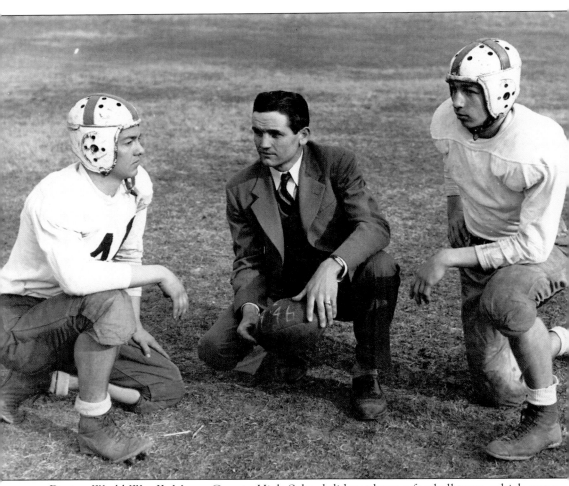

During World War II, Moore County High School did not have a football team, which was a result of many boys volunteering for the service and a lack of funds for a coach's salary. In 1944, though, some of the boys were able to convince the school's principal to revive the program if they could find a coach willing to work for free. Shirley Majors was working as a barber in neighboring Tullahoma but took the coaching job without pay. This was the beginning of a long and prosperous coaching career for Majors, who went on to coach at several local high schools and the University of the South in Sewanee. Majors is pictured here in 1946 with team captains Jack Hobbs (left) and Frank Bobo. (Courtesy of the Moore County Public Library.)

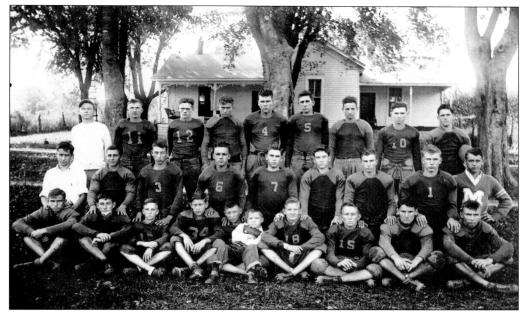

This photograph, taken between 1936 and 1937, depicts one of the last pre–World War II football teams at Moore County High School. During the war years, the football program at the school was nonexistent. The sparse padding in the uniforms is a reminder of how dangerous football was in the sport's early days. (Courtesy of the Moore County Public Library.)

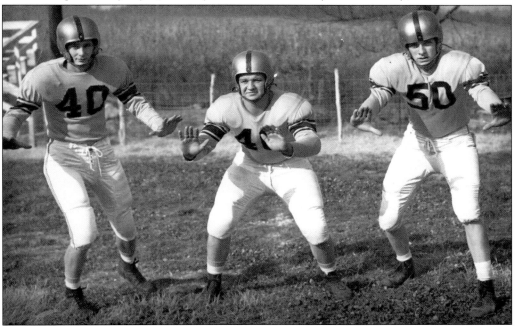

Members of the 1953 Moore County High School football team pose in a ready stance. Although still lacking compared to the equipment of today, the hard helmets worn by the players here undoubtedly aided in protecting them against serious head injuries. Pictured here are Milton Reese (left), Phillip Buntley (center), and Billy Fanning. (Courtesy of the Moore County Public Library.)

Mary Lee Brazier Thomas poses for a photograph in 1966 wearing her Lynchburg Elementary cheerleading uniform. Even today, Thomas is widely known as Moore County athletic teams' biggest fan. She and her husband, Ronnie, try to attend as many games as possible, particularly during football season. (Courtesy of the Moore County Public Library.)

The Moore County High School (also referred to as Lynchburg High School) baseball team poses for a photograph in front of the local post office in 1927. Because there was not a baseball field on school grounds, games and practices were held in the area now known as Wiseman Park, located behind the historic downtown square. (Courtesy of the Moore County Public Library.)

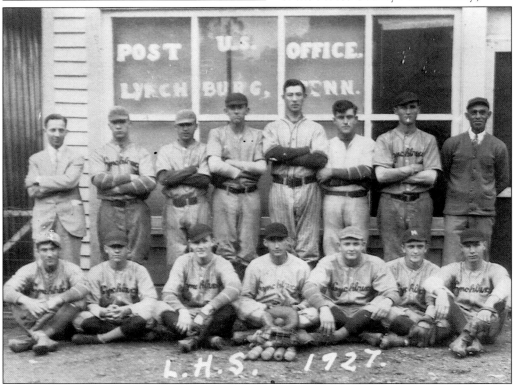

Athletics were not the only extracurricular activities available to Moore County students, as music and theater were among other student hobbies. Pictured at right is the playbill for the 1936 senior class production of *Call Me Mike*. This performance took place in the new auditorium built during the construction of the school on Mechanic Street a few years prior. Below is the Moore County High School Tiny Band in the 1960s. These young music enthusiasts enjoyed a moment of fame when they appeared on Nashville's Channel 8 News. (Courtesy of the Moore County Public Library.)

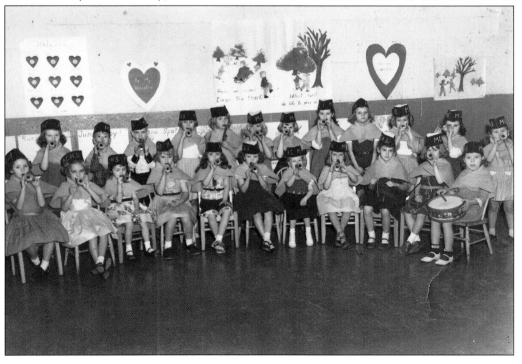

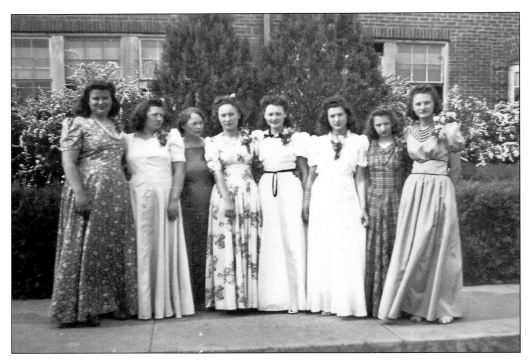

Homecoming festivities have long been an integral part of scholastic life in Moore County. Above is the 1941–1942 high school homecoming court. Pictured are, from left to right, Sarah Holt, Evelyn Chapman, Nell Tipps (teacher), Martha Norman, Eileen Hale, Audrey B. Simpson, Frances Anita Woosley, and Emma Hinkle. Below is the Moore County High School homecoming court for 1947. Among those pictured are homecoming attendants, escorts, other members of the football team, and cheerleaders. This image also reveals the stage inside the MCHS auditorium. (Courtesy of the Moore County Public Library.)

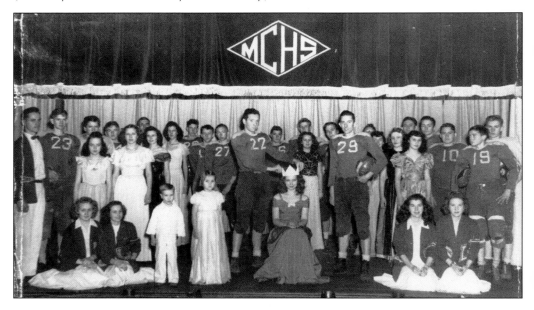

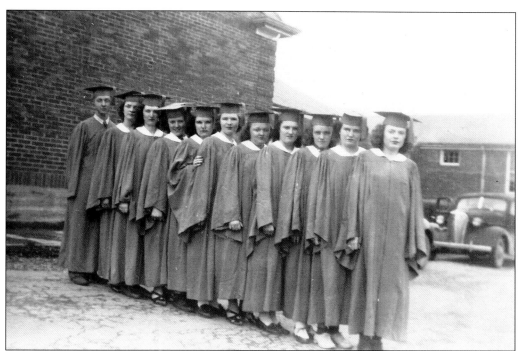

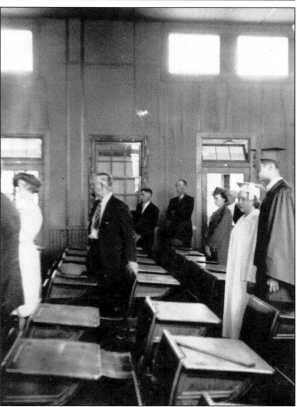

The 1945 graduating class at Moore County High School is pictured above. Members of the class are, from left to right, Emmett Sanders, Juanita Parkes, Crystal Bell Ingles, unidentified, Alice Head, Jewel Sisk, unidentified, ? Cunningham, Floy Womble, Virginia Gray, and Emily Spencer. This photograph also shows the exterior of the high school that was built in 1931. At right, Frances Stone (second from right) and Roy Sweeney (far right) prepare for commencement exercises in 1941. This image reveals the interior appearance of MCHS at the time. (Courtesy of the Moore County Public Library.)

It is tradition in Moore County for high school students to prepare floats as part of a parade during Homecoming festivities. Each class designs its own float, and the parade proceeds from the school through the downtown area. Even now, businesses along the square shut down, and school is let out early so that the entire community can participate. Above is a Homecoming float from 1956. Below is the graduating class of 1958. By this time, the rural schools were closing, and students from the outlying areas were attending elementary and high school in Lynchburg, as indicated by the increase in graduates compared to earlier photographs in this chapter. (Courtesy of the Moore County Public Library.)

This 1949 photograph shows the first Moore County High School graduating class on a visit to the nation's capital. This inaugural trip began a tradition of senior trips that continues today. Throughout the year, students raise money to help pay for the journey, which now includes a stay in New York City as well as Washington, DC. (Courtesy of the Moore County Public Library.)

This 1927 photograph of Moore County High School teachers includes English teacher Beulah Harris and home economics teacher Charlie Goodbar, but there is no indication of what order the ladies appear in. This photograph appears to have been taken at the old high school just before operations moved to the Holt mansion. (Courtesy of the Moore County Public Library.)

Guy Ervin, pictured here as a 1950 graduate of Peabody College in Nashville, taught school in Moore County and the surrounding areas for many years. As superintendent of schools in 1972, he directed the purchase of property from Fred and Frank Price for the new high school. (Courtesy of Louise Ervin.)

Ervin's new high school was completed in 1973, and for the first time in years the elementary and high schools were separated into different buildings. The new Moore County High School graduated its first class in 1973, and it remains the local high school today. Ervin is pictured here with his wife, Louise, on their wedding day of June 14, 1941. (Courtesy of Louise Ervin.)

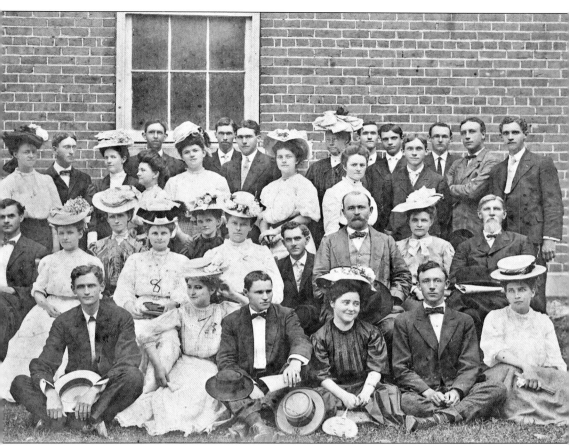

In the early schools, a college degree was not required to qualify as a teacher. Nonetheless, the Moore County Teachers Institute, held at the Moore County Courthouse, was established to aid certification candidates in preparing for qualifying examinations. Participants are pictured here in 1908. (Courtesy of the Moore County Public Library.)

Once a teaching candidate passed the required examinations, he or she was presented with a certificate. Above is one such certificate issued to Maude Bell in 1910. Bell was permitted to teach primary grades only, and the bottom of the certificate explains how students should be graded and advanced to the next respective grade. It is noteworthy that the superintendent of schools in Moore County, Cora Wiseman, signed the certificate. It was under Wiseman's direction that the first high school was established in Moore County. Below is Bell's contract to teach in the Davis School, located in rural Moore County. (Courtesy of the Moore County Public Library.)

Four

BUILDINGS
AND BUSINESSES

The architectural environment is the tangible expression of human culture and society and is perhaps best exemplified through the design and construction of homes, churches, and other public buildings. The architecture of the Lynchburg area contributes to its unique character, helping to shape, in turn, the businesses and civic organizations housed there.

A large part of downtown Lynchburg was placed in the National Register of Historic Places in 1996, creating the Lynchburg Historic District. Bounded by Main Street, Majors Boulevard, and South Elm Street, the district boasts some of the oldest and most elegant architecture in the area.

The rural areas of Lynchburg possess their own historic buildings with equally rich history. From churches to homes and homes that became businesses, the area around Moore County is a matrix of both the elegance of high style and the functionality of vernacular forms. With structures ranging from the small and simple cottage to the commanding presence of Greek Revival homes and the verticality and drama of Gothic Revival architecture, the communities in and around Lynchburg display numerous styles—and sometimes in surprising places.

The buildings on Lynchburg Square have endured two fires, one in 1883 and the other in 1913, while those in outlying areas have endured natural disasters that left visible evidence in the walls. This chapter looks at some of these buildings and the people and organizations that helped shape the civic and economic history around Lynchburg.

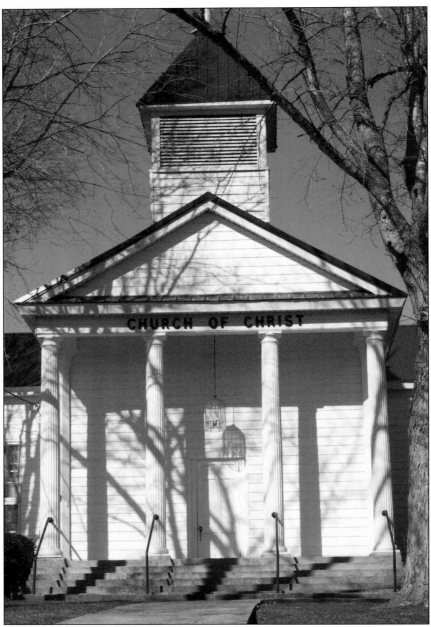

The Lynchburg Church of Christ, also known as Main Street Church of Christ, was built in 1849. In the church's early history, services were held on a monthly basis, and preaching duties were shared by Calvin Darnell and T.W. Brents. The original building was located on Main Street on the east side of the town square. When Moore County formed, the building was purchased for use as a courthouse, but it caught fire in December 1883 (a new courthouse was then constructed). This photograph depicts the Lynchburg Church of Christ that was erected in 1875 as it stands today. The church was built upon land that belonged to Dr. Ezekiel Salmon, the town doctor and surgeon. The members of this church were responsible for the establishment of additional congregations throughout the local area. (Photograph by the author.)

The Berry Chapel African Methodist Episcopal Church in Lynchburg was in existence as early as 1891. The church shared a pastor with the St. John AME Church in neighboring Mulberry. This photograph, taken at the Berry Chapel Cemetery, shows the headstone of Philip Reese (at right), who was born in 1828. (Photograph by the author.)

Arbor Primitive Baptist Church was among the earliest churches established in the Moore County area. It was originally a log building constructed on Ferris Creek; a frame building was erected in 1885. The church was moved to Lynchburg in 1959, and the building now serves as a funeral home. (Courtesy of the Moore County Jail Museum.)

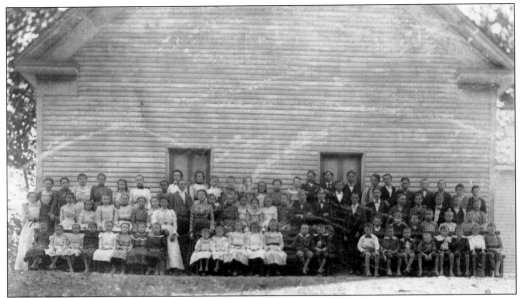

Members of the Oak Grove Church in the Fuga community pose for a photograph at an unknown time. Fuga was located about seven miles south of Lynchburg, close to Mulberry. The Fuga-Reed Cemetery, with headstones dating back to 1878, is located nearby. (Courtesy of Louise Ervin.)

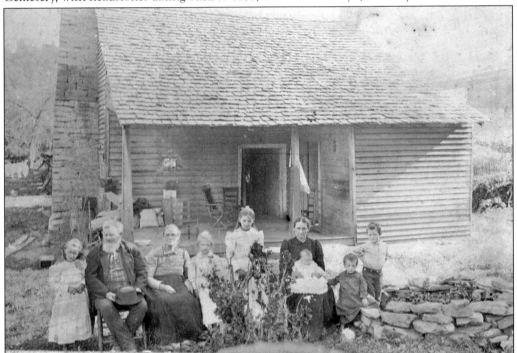

This 1896 photograph of the Smith home in Fuga shows, from left to right, Beulah Snow, James Reed Smith, Rebecca Syler Smith, Mimi Spencer, Nancy Elizabeth Snow, Margaret Catherine Smith (baby), Johnny Mae Snow, George Snow, and Hitie R. Snow. James served as postmaster from 1897 to 1905 and owned a general store in Fuga. (Courtesy of Louise Ervin.)

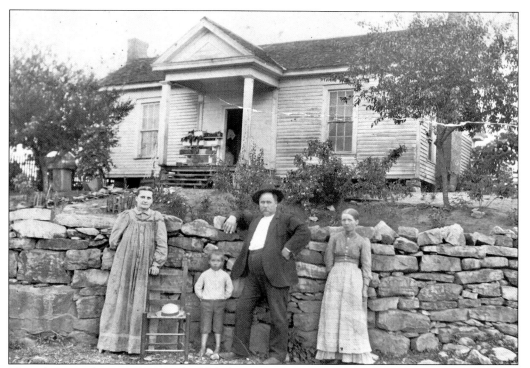

This photograph was taken at the Holt home in County Line. Pictured here are, from left to right, Jennie Wiseman Holt, John Bartlett, Thomas "Tom" Holt, and Callie Nobblitt. Tom owned a general store in the community. The house has since burned, but the stone wall still stands. (Courtesy of Louise Ervin.)

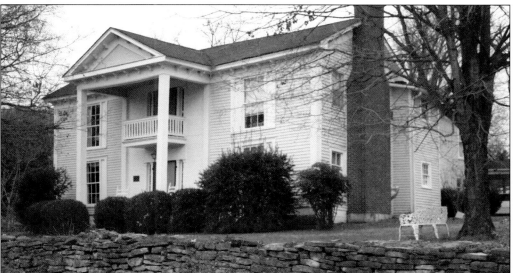

Constructed in the provincial Greek Revival style, this house was built in 1850, and the land has been in the Farrar family since before that year. The house, which is located in the Flat Creek area, now belongs to Isaiah "Ike" Farrar and is listed in the National Register of Historic Places. (Courtesy of Ike Farrar.)

Walton W. Holt, known as "High Bob," was a prominent businessman with numerous landholdings in Moore County. He was born in 1848 and served in the Confederate army during the Civil War. He later owned Holt and Hiles Dry Goods in Lynchburg and was associated with the early Farmers Bank. (Courtesy of Ike Farrar.)

Walton's wife, Susan Victoria Motlow Holt, was the daughter of Felix and Margaret Atkins Motlow, making her a first cousin to Lem Motlow, the longtime proprietor of the Jack Daniel Distillery. Felix Motlow was the youngest son of Agnes McElhaney Motlow, one of the earliest settlers in Moore County. (Courtesy of Ike Farrar.)

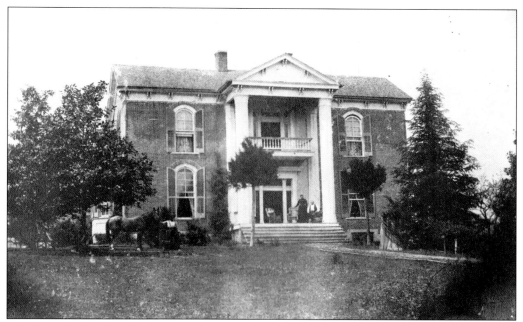

This house, known as the Holt mansion, was once the home of Walton W. and Susan Holt. It was built in the late 19th century on land bordered by Magnolia, Poplar, and Church Streets. The house served as the local high school from 1927 until 1932. (Courtesy of Ike Farrar.)

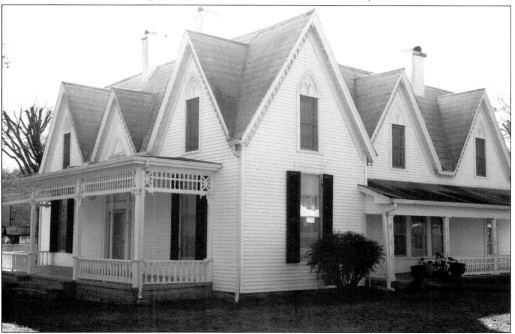

Locally known as the "House of 7 Gables," this home was constructed by Alfred Eaton in 1876 and is part of the Lynchburg Historic District. Eaton was a partner in one of the early whiskey distilleries, Eaton and Tolley. This house was later purchased by Walton W. Holt as a gift for his daughter Emma. (Photograph by the author.)

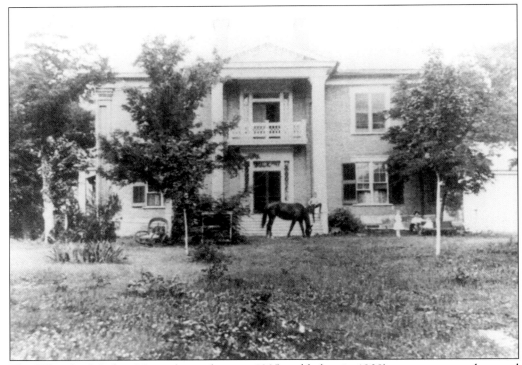

The Whitaker-Motlow House (seen above in 1905 and below in 1909) was constructed around 1850 by Newton Whitaker of Mulberry. Newton was the son of John Whitaker, one of the earliest settlers of Lincoln County. John established the earliest Primitive Baptist Church in Mulberry. In 1903, the house was purchased by Robert Lee "Bob" Motlow, a cousin of Lem Motlow (of the Jack Daniel Distillery). The photograph below shows damage caused by a tornado in 1909, with Robert Motlow surveying the damage. He was able to rebuild the house almost exactly as it originally was. In 1987, the house was purchased by Carl and Maria Maroney and restored. It is currently being incorporated into the National Register of Historic Places. (Courtesy of Maria Maroney.)

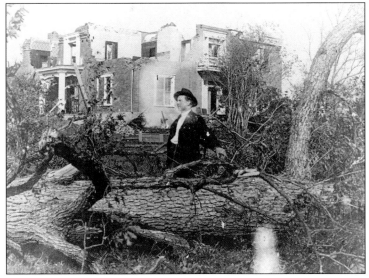

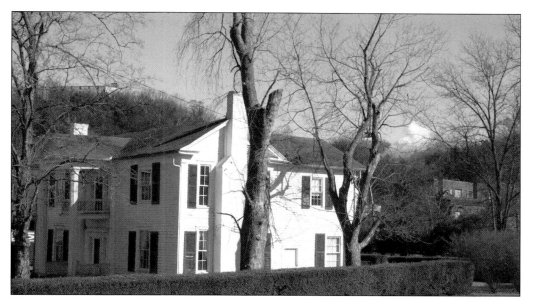

This is the house where Lem Motlow lived his last days, as his previous home burned down some time before. The house pictured here was built around 1870 and is directly adjacent to the Jack Daniel Distillery. Steam is visible rising from the stills, and a few of the distillery buildings can be seen behind the house. After many years as proprietor of the Jack Daniel Distillery, Motlow died in 1947. (Photograph by the author.)

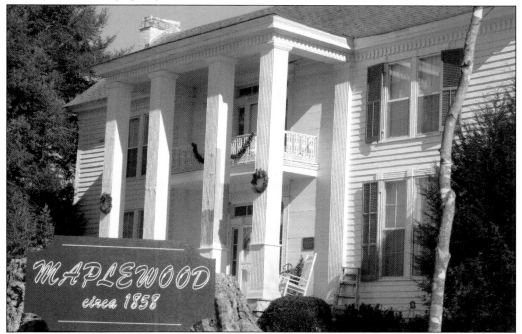

Built by Townsend Green in 1858, Maplewood was purchased by the Evans family in the early 1800s. It was the childhood home of Ophelia Evans, wife of Lem Motlow, and Mary Evans, who married Lacy Jackson Bobo. "Miss Mary," as she is widely known, was the longtime proprietor of the local boardinghouse. (Photograph by the author.)

The building that contains Miss Mary Bobo's Boarding House was originally owned by Thomas Roundtree, who was responsible for the establishment of Lynchburg. Roundtree constructed his home of logs, utilizing it as a tavern by 1820. The log structure was converted to brick by 1830. Dr. Ezekiel Y. Salmon purchased the property in 1850 and added the Greek Revival portico to the front. Dr. Salmon and his wife operated the Grand Central Hotel in the house until 1908, when they relocated to Nashville. Mary Evans Bobo and her husband, Lacy Jackson Bobo, purchased the hotel; she continued to operate it as a boardinghouse until her death in 1983 at the age of 101. The hotel was a popular hangout in Lynchburg and was frequented by the likes of Jack Daniel. (Courtesy of the Moore County Public Library.)

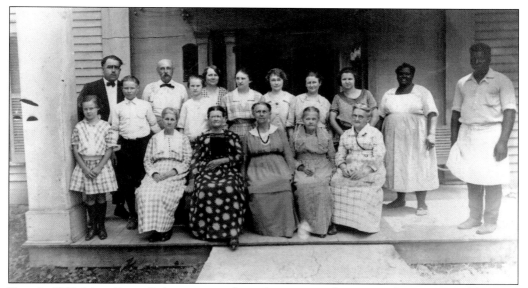

Born in 1881, Mary Evans Bobo was one of very few women who operated a commercial business during that era. Pictured here around 1923 is Miss Mary with staff, family, and a few boarders. Bobo is pictured in the back row, seventh from the right, wearing a checked dress. (Courtesy of the Moore County Public Library.)

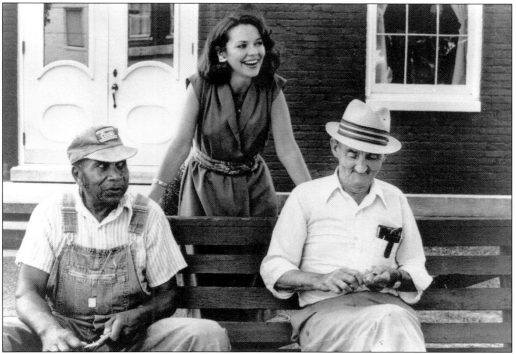

Although Miss Mary Bobo's no longer operates as a boardinghouse, the Jack Daniel Distillery bought the property in the early 1980s, and it continues to serve meals daily. Lynne Tolley is now the longtime proprietress of the establishment; she is pictured with "the whittlers," "Bitsy" Eady (left) and Lyndon Simpson. (Courtesy of the Moore County Public Library.)

John H. Taylor was born in 1801 and settled in Lynchburg in 1809. He likely built this house in the mid-19th century after his 1826 marriage to Elizabeth Ford. The house was later owned by Reagor Motlow. The Taylor-Motlow House is now operated as the Lynchburg Funeral Home. (Photograph by the author.)

This house in Lois was once the office of Dr. James Lamar Codie, who came to the area around 1885. Dr. Codie made house calls in the community on horseback. He died in 1919, and the house was later owned by Rufus and Mary Jane Sullenger Frame. It is now in the possession of Jack and Annie Lou Frame Tomlin. (Photograph by the author.)

The Moore County Courthouse was constructed between 1884 and 1885 and cost $6,875 to complete. The land on which the courthouse was built belonged to a Colonel Hughes and originally measured about two acres. The building is constructed of locally made bricks. One of the court's most dramatic trials was that of town marshal Hershal Scot. Scot shot and killed James "Jim" Silvertooth but was acquitted of the charges on the grounds of "justifiable provocation." The courthouse was enlarged in 1968 to include an additional bay on each side. Today, court is still held upstairs in the original courtroom. In this 1960s photograph, Thomas "Tom" Motlow, then president of the Farmers Bank, strides past the courthouse on his way to work. (Courtesy of the Farmers Bank, photograph by Joe Clark.)

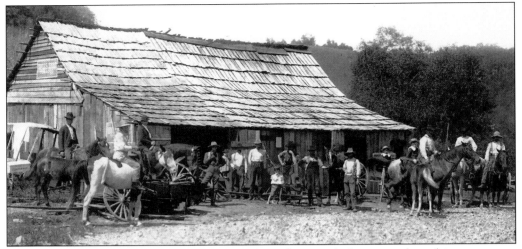

Patrons of the blacksmith shop at Fuga pause for a photograph. Images such as this one suggest that business was booming. To the right, on the spotted horse, is Booker Holman, an African American traveling preacher. Nearby, Thomas Lesley sits atop a horse with Frank Lesley behind him. (Courtesy of Louise Ervin.)

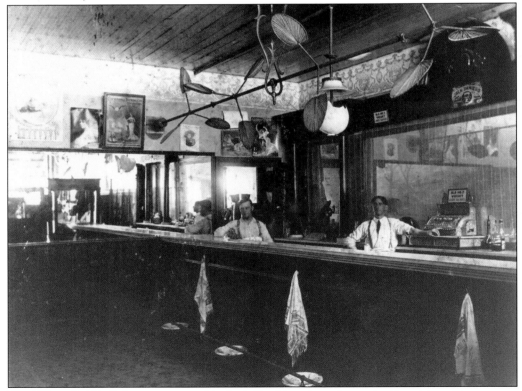

The White Rabbit Saloon was owned by Jack Daniel and was located at Lynchburg Square near his distillery. Here, bartenders pose for a photograph inside the saloon, which closed in 1909. The White Rabbit was later reopened as a restaurant but is now no longer in business. (Courtesy of the Jack Daniel Distillery.)

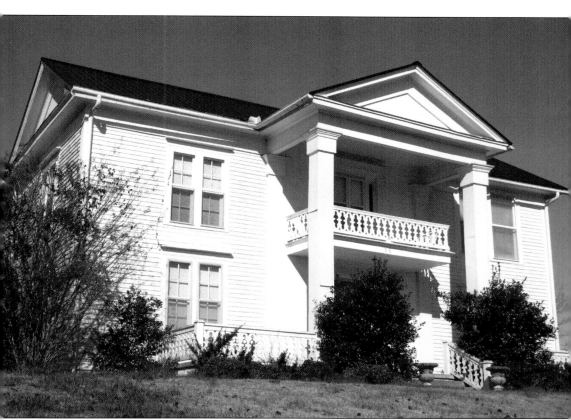

Built in a provincial Greek Revival style, this house was originally constructed as the home of J.L. Bryant, business partner of Henry Morgan. The house, located on Majors Boulevard, is part of the Lynchburg Historical District and is listed in the National Register of Historical Places. In the 1920s, the house was purchased by Dr. David McCord and transformed into a hospital. Dr. Jack Farrar also kept an office in the McCord hospital. When Dr. McCord died in 1941, the hospital's cook, a woman with the last name Gentry, purchased the house and lived there until 1950. The property was then bought by Guy and Louise Ervin and used as a residence until it was sold to their daughter Nancy and her husband, Buford Jennings. The Jennings Funeral Home opened in this building in 1990. (Photograph by the author.)

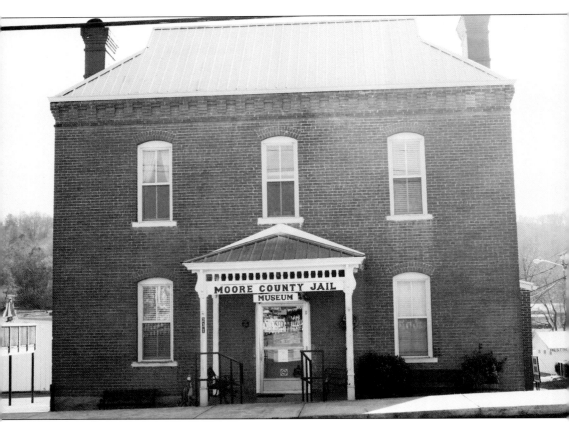

This building, completed in 1893, was constructed on a lot obtained by the newly formed Moore County government from Walton W. Holt for $650. The Pauley Jail and Manufacturing Company was hired to complete the construction, which included both inmate cells and a residence. The total cost of construction was just under $6,000. This building served as the Moore County Jail until 1990, when construction was completed on the new county jail. It was not the first jail built for the county: the original jail, locally known as the town "lock-up" or calaboose, was built of sturdy oak planks. The second jail was erected in 1875 on Mechanic Street and is now a private residence. After this jail closed, the Moore County Historical and Genealogical Society purchased the building for use as a museum, which continues to operate today. (Photograph by the author.)

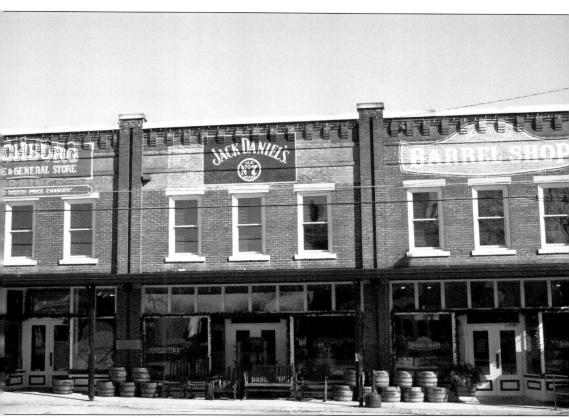

The Lynchburg Hardware and General Store (left) was once the offices of Dr. Stephen E.H. Dance. Downstairs, he and his son Dr. William Dance owned a drugstore. In 1974, the Jack Daniel Distillery acquired the building and opened the Lynchburg Hardware and General Store as a location to sell Jack Daniel's merchandise. The middle portion of the store was once the location of the White Rabbit Saloon, which was owned by Jack Daniel. The saloon closed in 1909 and eventually became part of the distillery property, allowing for the expansion of the Lynchburg Hardware and General Store. The Barrel Shop (right) is also owned by the distillery and is essentially a continuation of the Lynchburg Hardware and General Store. This portion of the building was once owned by the Motlow family and was, at one time, an actual hardware store. (Photograph by the author.)

Jasper Franklin "Spoon" Motlow was born in 1871 to Felix and Finetta Josephine Daniel Motlow. In 1901, Franklin, along with his brother Lem, arranged to purchase the controlling stock of the Farmers Bank (established in 1889) from its shareholders in Tullahoma. Franklin served as the second president of the Farmers Bank and held the position until his resignation in 1916. (Courtesy of Mary B. Motlow.)

Walton W. Holt served as the first president of the Farmers Bank when it was established in 1888 and held the position until it was taken over by Franklin Motlow in 1901. Before the bank opened, many area residents banked in Shelbyville or safeguarded their own money. (Courtesy of the Farmers Bank.)

Jack Daniel Motlow Jr. served as president of the Farmers Bank from 1969 until his death in 1973. Jack Jr. was the son of Jack Daniel Motlow (1889–1953) and Ella Louise Smith. Jack Sr. was the son of Felix and Finetta Josephine Daniel Motlow and brother to Lem Motlow. (Courtesy of Mary B. Motlow.)

Charles Ashby served as the Farmers Bank president from 1973 until 1983 and as chairman of the board from 1983 until 1997. The bank has weathered the panics of 1893, 1907, 1914, 1923, and 1930 without imposing limits on withdrawals. During the 1907 panic, Jack Daniel reportedly announced his backing of the bank in his two saloons, pledging that its patrons' money was secure. (Courtesy of the Farmers Bank.)

Thomas "Tom" Gregory Motlow was born in 1877 to Felix and Finetta Josephine Daniel Motlow. When two of his brothers, Franklin and Lem, purchased the Farmers Bank in 1901, Thomas was named its first cashier. He served in that position until 1916, when he was named president of the bank, a post he held until his death in 1969 at the age of 92. (Courtesy of the Farmers Bank.)

As recounted in this 1967 newspaper article, Tom Motlow was a student at Vanderbilt University in Nashville when he was named the cashier of Farmers Bank in Lynchburg. Motlow never married and was a longtime resident of Miss Mary Bobo's Boarding House. (Courtesy of the Farmers Bank.)

Originally a wooden frame structure upon its establishment in 1888, the current Farmers Bank of Lynchburg was built in 1921. This photograph shows the then president Thomas Motlow entering the bank in the early 1960s. Although it was rebuilt, the Farmers Bank has been at the same location—on the east side of Lynchburg Square—since its establishment. (Courtesy of the Farmers Bank; photograph by Joe Clark.)

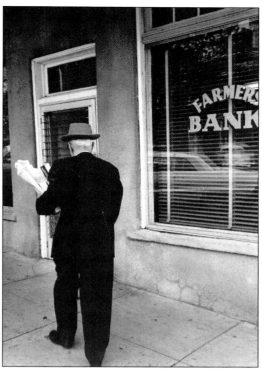

In this photograph, likely taken in the late 1920s, two women pose in front of the Lynchburg Post Office. Until 1896, rural communities had post offices in general stores; that year, the federal government created the rural free delivery system that provided free mail delivery to rural residents. Free delivery started in urban areas in 1863. (Courtesy of the Moore County Public Library.)

In the above image, Lucille Holt and her father, George Holt (center), are pictured with an unidentified man outside the storefronts that now comprise the Lynchburg Hardware and General Store and the Barrel Shop. In the photograph below, George and Lucille pose inside the Holt Grocery Store, located on the east side of Lynchburg Square. The store is believed to have later become the Holt Appliance and Furniture Store owned by Marion Charles Holt. Lucille was married to Parks Hayes, the local postmaster. (Courtesy of the Moore County Public Library.)

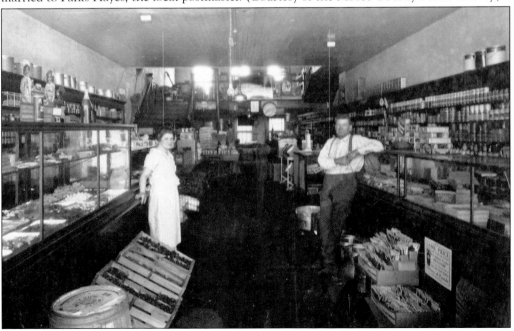

The Iron Kettle Restaurant has become a Lynchburg institution and is considered the local hangout. The restaurant's Coffee Club, pictured here, meets every morning for breakfast and lively discussions. The club has designated the Iron Kettle as the "Local Yokels' Meetin' Hall, where wars are won, problems are solved, and lies are swapped." (Photograph by the author.)

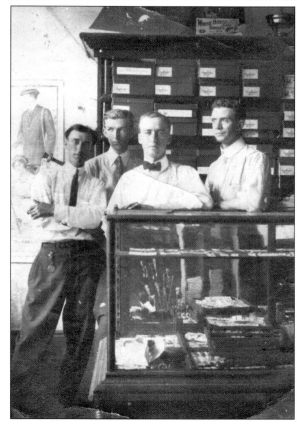

Businesses have successfully operated in Lynchburg and the surrounding area since 1812. The two earliest recorded stores in town were owned by William Long and a Mr. McJimsey and were operational before 1820. The unidentified men in this photograph pose inside one of Lynchburg's many stores during the early 20th century. (Courtesy of the Moore County Public Library.)

The first public library established in Moore County was a 400-square-foot frame building that still stands on Majors Boulevard in Lynchburg. This building was dedicated as the local library in 1953, and it had 2,458 books in circulation by 1954. The current public library, seen here, was built in 1963 and was gifted to the county by Reagor and Jeannie Motlow. Along with the Motlows, other community members donated furnishings and supplies for the library. The building was erected close to Lynchburg Elementary School so the children could reach it without crossing any busy streets. Today, the Moore County Public Library serves the local community in numerous ways. Librarian Peggy Gold provides numerous enrichment programs for families and children, and library-card holders can access the Internet for free. The library contains a wealth of information on local and state history, with books ranging from family genealogies to church histories. (Photograph by the author.)

Five

The Modern Years

Recent decades have seen extensive changes to the way of life in and around Lynchburg. Although the town's population remains small, the number of residents has consistently grown. In 1987, the public voted in favor of converting the county into a metropolitan government. Therefore, in January 1988 the city of Lynchburg merged with the county to create Metropolitan Lynchburg-Moore County.

Although it was advertised for decades on bottles of Jack Daniel's whiskey as having a population of 361, the 2010 census reported that Metropolitan Lynchburg Moore County actually has 6,362 residents. The county originally contained 11 civil districts; these were changed to five council districts when the metropolitan government was created.

Despite these changes and the fast-paced, technology-driven modern lifestyle, Lynchburg still has only one stoplight, and life continues to move at a fairly slow pace. Many older traditions, such as Frontier Days, are continued today, and several local businesses (like the Lynchburg Drug Store) have served the community since its early history.

This chapter briefly explores the recent past of the areas around Lynchburg and attempts to reveal some of the changing and continual aspects of the area. People, places, events, and traditions are included in an effort to not only reflect upon where Lynchburg has been, but also to predict where it is going in the future.

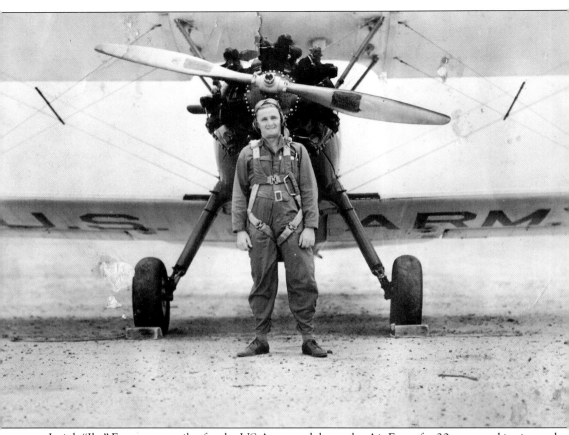

Isaiah "Ike" Farrar was a pilot for the US Army and, later, the Air Force for 20 years and is pictured here after his first solo flight in April 1942. Farrar was a member of "The Pinks" of the US Air Corps. The group received the nickname because of the pink hue of their uniforms. He served in the Pacific during World War II and later returned home to his family farm. Today, at the age of 92, Farrar can distinctly remember flying into Manila when the *Enola Gay* dropped the atomic bomb on the city of Hiroshima in Japan. He also recalls being in the air when a "radio man" dispatched the ending of World War II. He fondly recounts the time he spent flying with Gene Autry, the famous cowboy. Farrar, the son of Thurston and Clara Holt Farrar, currently resides on the Farrar farm just outside the Flat Creek community. (Courtesy of Ike Farrar.)

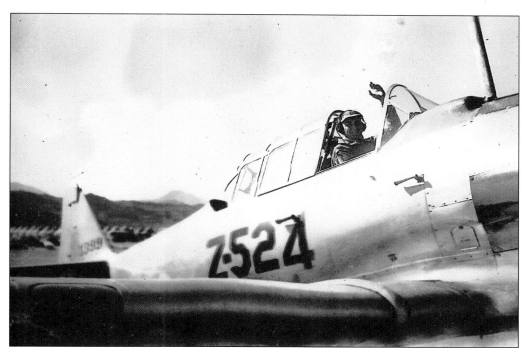

The above photograph shows Isaiah Farrar in 1943 at his first job as a pilot; he trained machine gunners for the US Army at Kingman, Arizona, and Indian Springs (Las Vegas), Nevada. In 1946, he married Mary Catherine Arnold, seen at right, of Williamson County, Tennessee. Arnold had been voted the prettiest girl in her home county and was working as a colonel's secretary when she met Farrar. With one of the greatest pick-up lines in history, Farrar told Arnold that he had once been a scout for Metro-Goldwyn-Mayer Studios and that she would make a great stand-in for Dorothy Lamour. (Courtesy of Ike Farrar.)

Pictured below are, from left to right, Annie Lou Frame Tomlin, Virginia Frame Amacher, Wallace Brazier, and Brazier's son Phillip. At left is Evelyn Frame Thomas Whitmire, sister of Annie Lou and Virginia. In 1939, the Frames moved from Fuga to this house in Lois. While living in Fuga in 1930, the family's house was destroyed by fire but rebuilt with lumber donated to the family by the Will Grammer Saw Mill. Rufus Frame, the girls' father, was a farmer and cattle trader. At one time, Rufus traded cattle for the Jack Daniel Distillery. The property in Lois had two springs, where people from the community came to fetch water at sundown. (Courtesy of Annie Lou Tomlin.)

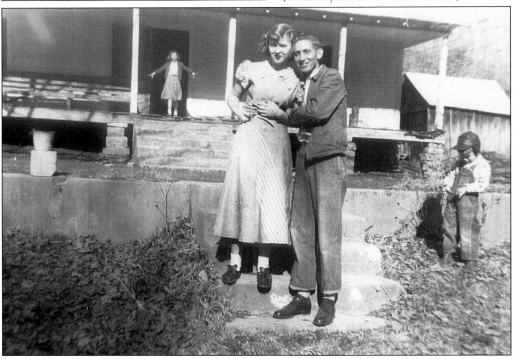

Lynchburg has long held an annual beauty pageant. Today, the pageant is sponsored by the senior class of Moore County High School, and the money raised goes toward the class trip to Washington, DC, and New York City. This photograph shows Nancy Ervin Jennings at the 1958 pageant. (Courtesy of Louise Ervin.)

The Lynchburg area has a long history of fine equestrian breeding and has hosted numerous horse shows and rodeos. Lem Motlow, of the Jack Daniel Distillery, was a first-class breeder of Tennessee Walking Horses and won many competitions. In this early-1980s photograph, John Tomlin shows off a trophy from a win at a local horse show. (Courtesy of Annie Lou Tomlin.)

Jeanie Garth Motlow, pictured here in 1936, was born in 1896 in Union City, Tennessee. She attended the University of Tennessee, Knoxville, and earned her degree at Vanderbilt University. She first taught school in Athens, Alabama before moving on to Union City, Tennessee. She married John Reagor Motlow, son of Lem and Clara Motlow, in 1928 and began teaching at the school in Crossville, Tennessee. Reagor Motlow was a state legislator and was deeply passionate about public education. Along with other members of the Motlow family, Reagor and Jeanie helped establish Motlow State Community College in Moore County. The college was constructed on 185 acres donated by the Motlow family and began enrolling students in 1969. Jeanie and Reagor were also instrumental in the creation of the Moore County Public Library. (Courtesy of the Moore County Public Library.)

Jeanie Motlow Memorial Reading Room

The Jeanie Motlow Memorial Reading Room, seen above, is located inside the Crouch Learning Center at Motlow State Community College in Moore County. Motlow received state recognition for her efforts to promote public libraries and reading programs. In 1954, she served as the first chairperson of the Moore County Library Board, and she later served 16 years on the Tennessee State Library and Archives Commission. At right is the program for the dedication ceremony of the Jeanie Motlow Memorial Reading Room, which was held on July 10, 1992. Motlow died on August 17, 1989. (Courtesy of the Moore County Public Library.)

Jeanie Garth Motlow
1896 - 1989

Union City
Tennessee Native

Married
J. Reagor Motlow
1928

Teacher
Union City High School
Athens College
and Cumberland Homestead

DEDICATION CEREMONY
JULY 10, 1992
2:00 P.M.

WELCOME	Dr. A. Frank Glass
	President, Motlow State Community College
INVOCATION	Rev. David Spencer
	McKendree Memorial Methodist Church, Portland
INTRODUCTION OF SPEAKER	Senator Ernest Crouch
	Former Senator, State of Tennessee
DEDICATORY REMARKS	The Honorable Bryant Millsaps
	Secretary of State, State of Tennessee
ACKNOWLEDGMENT	Video on late Jeanie Motlow
REMARKS	Dr. A. Frank Glass
BENEDICTION	Rev. David Spencer
	McKendree Memorial Methodist Church, Portland
RECEPTION	Learning Center

This 1940s photograph shows Moore County sheriff Curtis Sawyer and his mother, Della Hazlett Sawyer. Curtis was born in 1895 and served as sheriff from 1932 until 1936. Thomas Walter Wiseman replaced him as sheriff and served three consecutive terms, which ended in 1950. Curtis died in 1956. (Courtesy of Bettye McNeil.)

In this photograph, Tennessee governor Lamar Alexander cuts the ribbon on the newly constructed gazebo during Tennessee Homecoming festivities in 1986. The governor is joined by Nathan Osborne, at right, mayor of Lynchburg. The man on the left is unidentified but is believed to be the leader of the band seated behind the ribbon cutters. (Courtesy of Bettye McNeil.)

In this photograph, local residents and business owners survey the remnants of their buildings after the Great Fire of 1913. The fire began on the east side of the square, which is pictured, and spread to the south side. The entire eastern portion of the square was destroyed, as well as most of the southern part. The flames stopped when they reached the concrete walls of the Moore County Bank. (Courtesy of the Moore County Public Library.)

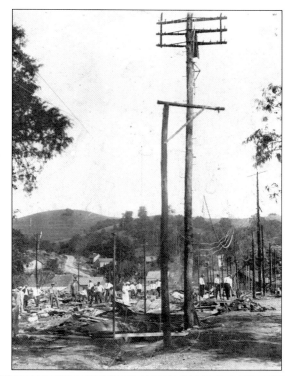

This 1955 photograph was taken during a gospel-singing event at County Line Baptist Church of Christ. This church was established before 1825 and had 46 members at the time. This event was one of many held over the years. The crowd was so large this particular day that pews had to be moved outside to accommodate the attendees. (Courtesy of Louise Ervin.)

The 4-H program has been active in the Lynchburg area for many years. Pictured at the Farrar family farm in Flat Creek, William (left) and David Farrar pose with their first show cow, a Hereford that won third place in the local 4-H competition. (Courtesy of Ike Farrar.)

Longtime members of the Grand Ole Opry Jimmy C. Newman (right) and Cajun fiddler Rufus Thibodeaux visited the Farrar home in Flat Creek for dinner, followed by a private performance. As a young man, David Farrar's first job was showing cattle for Newman. (Courtesy of Ike Farrar.)

Walt (right) and Todd Jennings pose on their family farm in February 1973. Located in the County Line community, the farm has been owned and operated by the family for over 100 years and is now designated as a Tennessee Century Farm thanks to a state program that recognizes and honors farms that have been consistently owned by a family for a century or more. (Courtesy of Louise Ervin.)

Sloan Stewart, pictured here in 2011, is the current mayor of Metropolitan Lynchburg Moore County. When the city and county merged in 1987, the office of Lynchburg mayor was changed to "metro executive" and remained that way until 2010. At that time, the office was again renamed to "metro mayor." (Photograph by the author.)

Lynchburg Frontier Days is a community event organized by the Lynchburg Chamber of Commerce. The photograph above depicts the founders of Frontier Days at the town's first celebration in 1965. The idea for the event was conceived by Harold Pool, then president of the chamber of commerce, after he saw advertisements for the "Rodeo and Frontier Days" celebration held in Cheyenne, Wyoming. During Frontier Days, Lynchburg Square, along with Wiseman Park, bustles with crowds of people, live bands, dancers, and in recent years carnival rides. In the early days, locals donned costumes for the occasion, as seen below in the 1975 photograph of the Farmers Bank employees, and contests were held in categories such as "Best Dressed Window." (Above, courtesy of the Moore County Public Library; below, the Farmers Bank.)

BIBLIOGRAPHY

Bradley, Michael R. *Nathan Bedford Forrest's Escort and Staff.* Gretna, LA: Pelican Publishing Company, Inc., 2006.
Green, Ben A. *Jack Daniel's Legacy.* Nashville, TN: Rich Printing Co., 1967.
Moore County Heritage Book Committee. *The Heritage of Moore County, Tennessee, 1871–2004.* Waynesville, TN: County Heritage, Inc., 2005.

DISCOVER THOUSANDS OF LOCAL HISTORY BOOKS FEATURING MILLIONS OF VINTAGE IMAGES

Arcadia Publishing, the leading local history publisher in the United States, is committed to making history accessible and meaningful through publishing books that celebrate and preserve the heritage of America's people and places.

Find more books like this at
www.arcadiapublishing.com

Search for your hometown history, your old stomping grounds, and even your favorite sports team.

Consistent with our mission to preserve history on a local level, this book was printed in South Carolina on American-made paper and manufactured entirely in the United States. Products carrying the accredited Forest Stewardship Council (FSC) label are printed on 100 percent FSC-certified paper.